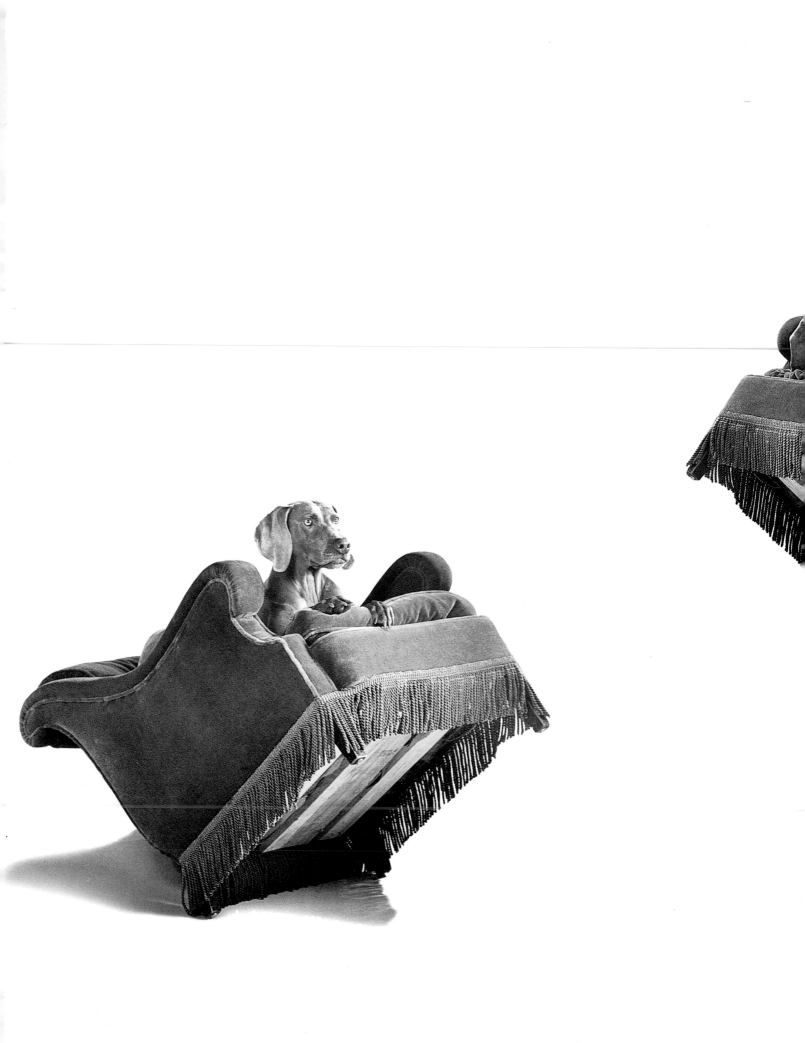

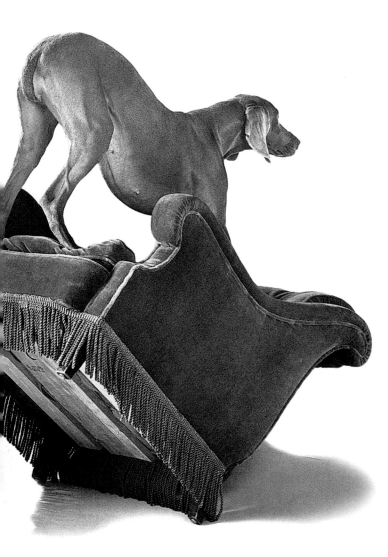

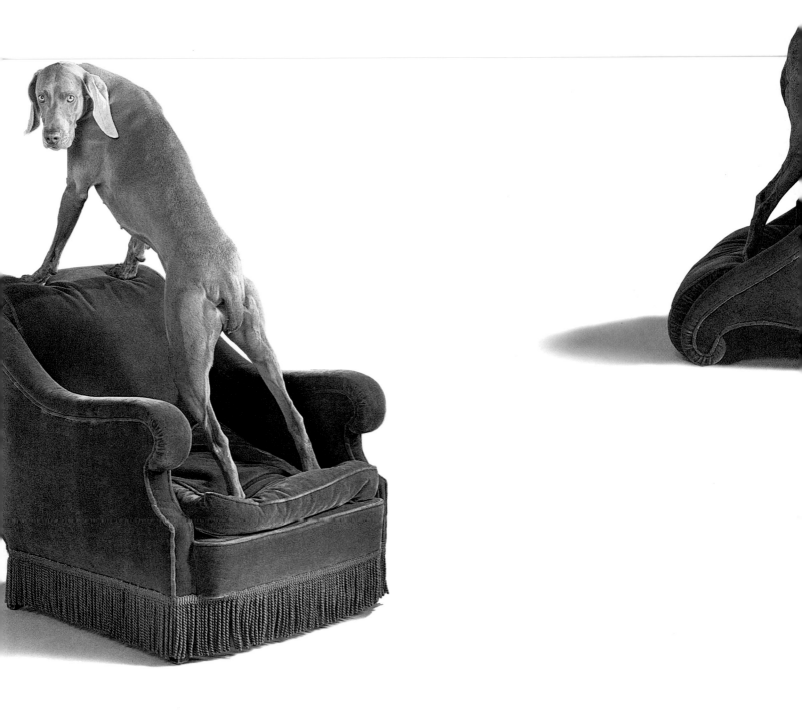

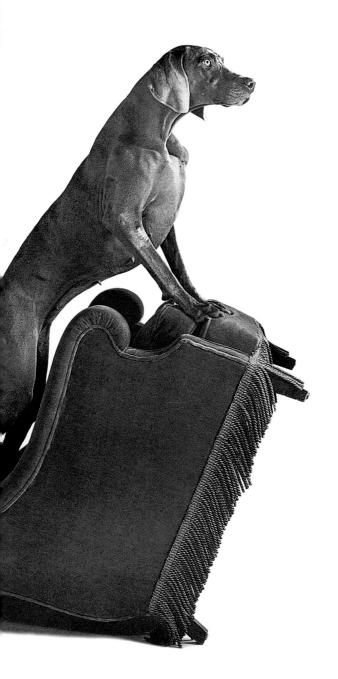

Fay William Wegman

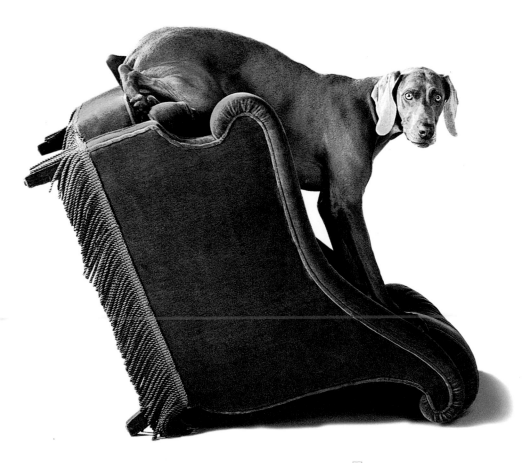

HYPERION

NEW YORK

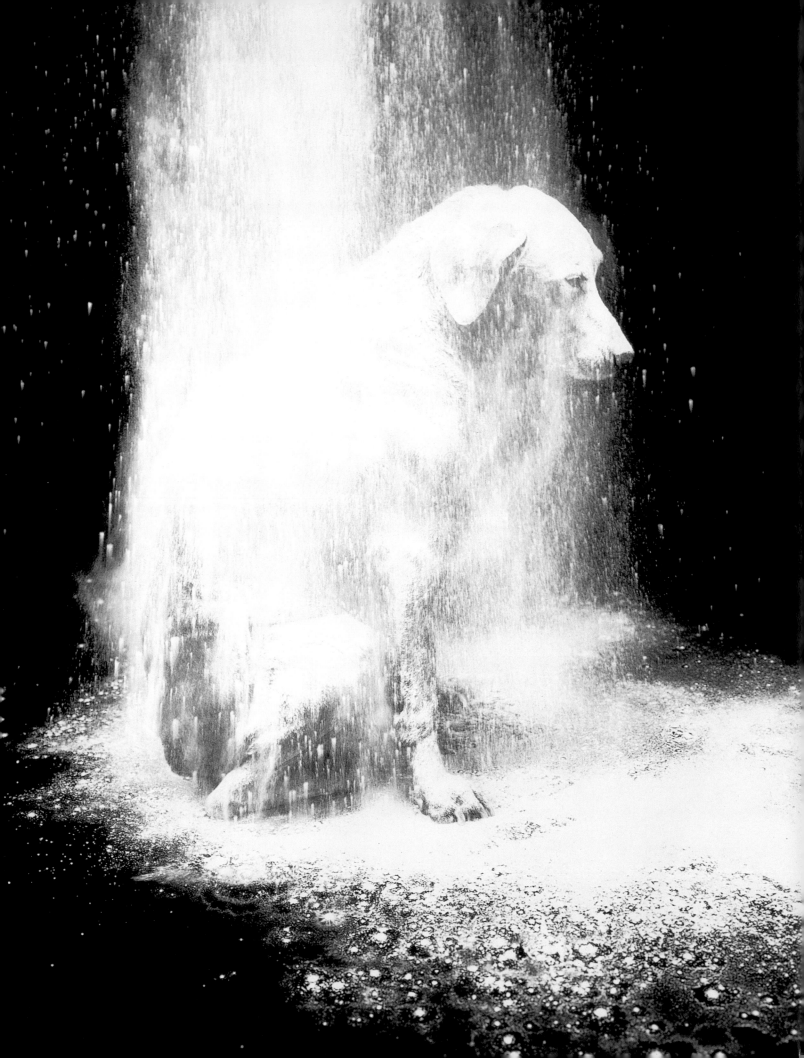

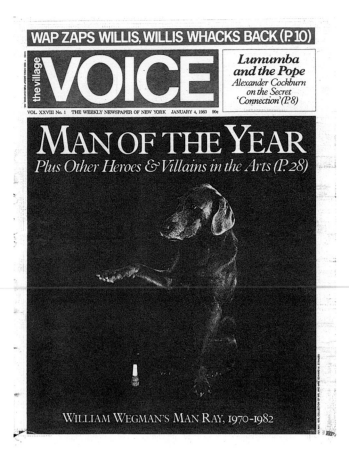

Before Fay there was Man Ray. Man Ray and I had been famous together. We went on talk shows. Without him I went unrecognized. On Saturday, March 27, 1982, he died. In January his picture appeared on the cover of the *Village Voice*. Man of the Year. I saw it in bundles on every street corner in New York. I never felt more alone.

I decided not to get another dog. Man Ray was irreplaceable. Then there was the dream. In the dream he appeared alive and well. Startled, I asked him where he'd gone? He would never say. I was happy. Ecstatic. Suddenly he would stumble and break apart, dissolving into blood before my eyes. I would wake up grief-stricken.

A couple of years and some months went by. I started to paint again. Not dogs. Anything but. I wanted to be far away from dogs. I got used to the idea of not having a dog. In a way it was kind of a relief. I could travel. I hate to travel.

Dusted,
1981

7

In the fall of 1984 I got a letter from the
art department at Memphis State University
inviting me to speak about my work. The
series—which included Dennis Oppenheim,
Eleanor Antin, and myself—was titled *Realism
and Reality in Postmodern Art.* I was all set
to go when a freak snowstorm in Memphis
forced a cancellation of my trip. An anxious
Melinda Parsons, the series organizer, called
to reschedule my talk. I was hesitant. When
it comes to air travel I'm Mr. Sweaty Palms but
the five-hundred-dollar honorarium sounded
good. I packed a slide carousel and selected
video works in my overnight bag. I left from
La Guardia on Friday, April 26, 1985.

The weather was terrible, the sky wild
with storms and turbulence. After two terrify-
ing hours of bouncing through the sky we,
the pilot, crew, and fellow passengers, landed
at Memphis International. A relieved and
happy Melinda Parsons met me at the gate.
How was your flight? Great.

I checked in at the campus motel to
unpack and throw up. Melinda picked me up in
half an hour and delivered me to the university
campus. Driving past the buildings had a calm-
ing effect on me. We parked and entered the
building where I was to give my presentation.
I saw my name and a picture of Man Ray on a
poster in the lobby. Was I in the art department?
No—psychology. Why? I never found out.

REALISM ᴚƎⱯ⅃ITY
IN POST-MODERN ART
THE SPRING SPEAKER SERIES
MEMPHIS STATE UNIVERSITY ART DEPARTMENT

MAN RAY, 1979

WILLIAM WEGMAN
5 FEBRUARY 1985
"Recent and Selected Video Work"

7:00 P.M.
Psychology Auditorium
Memphis State University

POWER FINGERS

DENNIS OPPENHEIM
4 MARCH 1985
"Realism and Abstraction"

7:00 P.M.
Psychology Auditorium
Memphis State University

ELEANOR ANTIN AS THE KING

ELEANOR ANTIN
15 APRIL 1985
"The Theatricalization of the Self"

7:00 P.M.
Psychology Auditorium
Memphis State University

Original poster for lecture
that actually took
place April 1985

Following pages:
Slide presentation, 1985

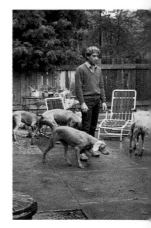

After my presentation I answered questions. Hands shot up. Was I going to get another dog? No. Probably not. If I did get another dog it would be a pet, not an art partner. My work with Man Ray was complete. There was nothing left to add. After a few more questions and answers I thanked everyone and left the stage. A woman, probably a teacher, toting a copy of my book *Man's Best Friend* came forward. She "loved" my work, even the paintings, she said effusively. She saw in the photos how much I loved Man Ray. She knew that I missed him. She introduced herself as Jeannette Ward, a professor in the psychology department at the university and, it so happened, a breeder of weimaraners. She invited me to visit her home and meet "the weims." *Weimaraners of Fancy,* her card read. I wasn't sure I had time.

Then she offered me one of her puppies. "It would be an honor," she said. I was stunned but found the words: no, thank you. I wasn't ready for a dog just yet. I'd like to see them though. There's no harm in looking. How about tomorrow morning? My flight leaves at noon.

The next morning it was still raining. I checked out of the motel. Melinda picked me up and brought me to Jeannette's home, conveniently located on the way to the airport. She lived in a regular house, as I recall, with a separate two-car garage, a porch, and a grassy fenced-in area. I was met by Jeannette and her son John.

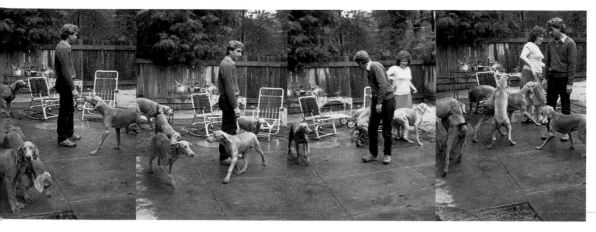

Memphis, Tennessee, April 27, 1985
The home of Jeannette Ward.
Photo: Melinda Parsons

There were dogs everywhere. In the yard, in the garage, in the driveway, on the porch, in the house. Everywhere. I was surrounded by them. Choose me! Pick me! I'm the one. Take me home. I'll be your dog. "That's a great little bitch over there," said Jeannette, pointing to a puppy on the porch. It's proper to call female dogs bitches but I'll never get used to it. I guess I'm not a real dog person. "Yes, she is. Hi girl," I said patting her on the head before moving over to another one. Her sister? "Hi pretty girl." They were not young puppies, they looked to be about six months old. At that age you can pretty much tell what they're going to look like as adults. This pup had a nice top line and a sweet expression but kind of a pointy head, I thought. I was pretty ignorant about form, not knowing withers from paddocks. I was a head-hunter. I liked the big head and full stop like Man Ray's. She said I had bonded with Ray. He had looked intelligent. He was intelligent.

13

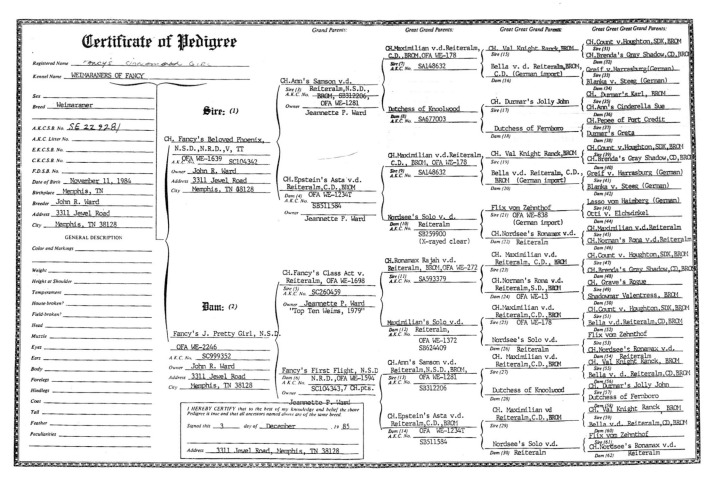

Fay's (aka Cinnamon Girl) Lineage

Damp dogs smelling like wet sweaters covered me as I knelt down to pat them in the rain. What seemed at first like thirty dogs was more like eight. This was fun. I didn't have to worry about choosing a puppy. I was just looking. I could just enjoy the moment. Then I saw her. I zoomed in on her amidst a rush of swirling gray. She had the eyes of a jungle cat, round, opalescent, yellow, unfathomable, a young lioness by Rousseau. She was looking up at me. As I knelt down to pick her up she momentarily vanished. That one? Her gray coat was a little brownish—more taupe than the others. Kind of a cinnamon color. "That's Cinnamon Girl," said Jeannette, pointing her out again. "Like the song." The name didn't ring a bell. I had to tear my eyes away to stop staring at her. Blindly I looked at some other dogs that Jeannette encouraged me to notice. There were a lot of girls as I recall and a couple of boys. Jake? Jasper? I can't remember. There were no Rays.

I didn't have much time. My flight was at noon. I thanked Jeannette for the entertaining visit and left for the airport. It was still raining. Turbulence.

Fay's Granddam:
CH. Epstein's Asta V.D. Reiteralm, CD "Maggie"
Photograph: William P. Gilbert

Fay's Grandsire:
CH. Fancy's Class Act V.D. Reiteralm

At 25,000 feet I could not get Cinnamon Girl out of my mind. Was she thinking of me too? How did that song go? I made up my own. The plane landed. The flight had not been bad. I almost called Jeannette from the terminal. In the taxi home from La Guardia I came to my senses. Close call. That night all night long I dreamt about her. Fay Ray. I would name her. At 9 o'clock on a Sunday morning in April I made the call. "Jeannette. Send Cinnamon Girl."

I had to wait. May was unusually hot in both cities, delaying Fay's arrival. You can't fly crated animals if it's above a certain temperature on the Tarmac. Finally, two weeks later, the call came. Fay would arrive from Memphis, on May 11, at La Guardia.

I want to write that the meeting was spectacular, emotional, full of joy. It wasn't. Fay was a mess. Her crate was a mess. Fay was shaking and crouching in fear. I brought her to her new home, my studio, a converted synagogue/Ukrainian social club on East Sixth Street in New York's soon to be briefly trendy East Village. She looked great lounging on my queen-sized bed, her amber eyes glowing serenely in the satiny splendor of her noble head. What a beauty! She slept under the covers.

At East Sixth Street Fay had the use of an adjacent yard, quite a large one by city standards. Completely enclosed, the area included the back yards of ten building lots between Sixth and Seventh streets, First Avenue and Avenue A. There were many cats and one big tree, a New York City tree teeming with squirrels. Fay liked chasing them. Unfortunately the lot was also full of debris despite occasional spirited communal efforts to clean it up: broken bottles, appliances, boards with nails, black grimy oil-soaked dirt, anything that the custodians of the other buildings felt like pitching out. So I began taking Fay to Tompkins Square Park where she could play ball off the leash in cleaner surroundings and meet other dogs. While not overtly outgoing she seemed to like most other dogs and certain people. The park was good. Getting there was an ordeal.

East Sixth Street Studio

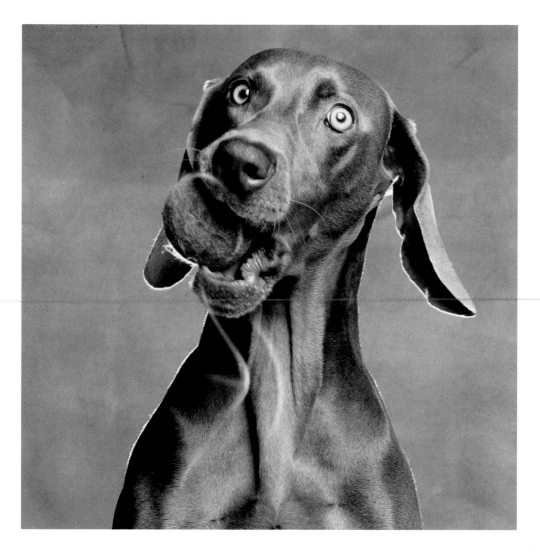

She was on the constant lookout for danger. If, God forbid, someone bumped a garbage can while we were passing or even worse pulled a metal gate up or down she would spiral out of control like a downed helicopter. One day in the park she bolted. Something had scared her. She charged home like a crazy horse, slicing through two lanes of traffic on Avenue A. Miraculously she made it. I found her panting and foaming at the door. Inside she curled up under the cover of my desk. It seemed she was happy only in the safe haven of the studio and her junk-filled yard. I had made a huge mistake. After two weeks I was ready to call Jeannette. I took out the dime and practiced my plea.

Please take Cinnamon Girl back.

Then came the tennis ball. It came rolling out of an overturned can and Fay pounced on it. With a look of glee she brought it back to me and I tossed it back to her. She brought it back to me. I tossed it back to her. She brought it back to me and I tossed it to her then she brought it back to me and I tossed it to her then she brought it back to me and I tossed it to her then she brought it back to me and I tossed it to her then she brought it back to me and I tossed it to her then she brought it back to me.

From that moment there was joy. There was hope. We played ball every day. In the house and in the cruddy yard.

Fay and I needed a place in the country.

David Deutsch, who for as long as I have known him has always had Labrador retrievers, was also looking. He found some farmland for sale about two hours' drive upstate in Columbia County. It was interesting property, adjacent to an apple orchard and a dairy farm. There were about three hundred acres of hay fields, cornfields, woods, a stream, and a couple of barns. I could buy a parcel and build a painting studio. The dogs would love it. This would be a weekend place. Or, being self-employed, an anytime place.

My wandering-surfer-artist-carpenter-friend Randy Johnsen would build the studio. Randy was one of my most gifted students at Cal State Long Beach. I gave him an A for fixing my Buick Skylark. Pure genius. Anything he did was art. Randy had recently re-renovated my Sixth Street space. Randy could make things and he could talk to people. He could get things done. He had a dog named Charlie, a black-and-white everyday dog who knew both Man Ray and Fay. Fay liked Charlie. If you knew Randy you knew Charlie. They went everywhere together including all over the world in search of surf.

After the property agreement was settled, Randy, Charlie, Fay, and I drove up in the Skylark to explore possible building sites. It was snowing. We parked by an old barn just off the road and stomped around the field picturing the perfect place, oblivious to the snow that was beginning to collect.

I had more than thirty acres to consider between a ridge to the west and an apple orchard to the east. I was inspired by the view from the ridge overlooking the Hudson valley. Randy being practical talked about water, power, and septic tanks, which led us to a field at the end of an abandoned farm road. Access, drainage, electrical power versus view. We went back and forth until I realized that upon the arrival of maple leaves in late spring there would be no view of the valley at all, and I wanted to be as far from the road as possible so I ditched the idea of the grand view. Thirty acres in the middle of a thousand. The main road was out of range. I would not have to worry about Fay and cars. Speaking of Fay, where were the dogs? It was getting dark and beginning to snow hard.

Hollering their names, we spread out looking for tracks. There were no tracks. Snow had covered all traces. I had a bad feeling. Randy wasn't too worried. Charlie was a wanderer. He always came back. Came back? To what? There were few neighbors— a white colonial at the foot of the road, an old farm, and across the road two other houses. What could the dogs come back to? Randy and I both lived in New York City. They could be anywhere. How long had they been gone? Two or three hours? Four? It was now dark and still no sign. I felt sick. What would I say to Jeannette Ward? Kevin, the guy in the colonial, joined the search party. He said we could camp out at his house. Randy drove off in the Skylark widening the search. I stayed near the house. I used up my wishes.

The storm became a blizzard. Eleven hours and not a clue and there was nothing to do but stare out the window and fret. At 1:30 a.m. a car pulled up. Kevin. He had seen a dog about two miles up the road. Fay!? He thought so. She was scared and would not get in his car. What about Charlie? No. He had not seen him. I looked over at Randy and felt bad. You can only lose *your* dog. I got in the car with Kevin. My heart raced. Would she still be there? The drive in the snow took forever. Then I saw Fay in the beam of the car's headlights. She was crouching by the side of the road in the parking lot of an insurance office. Fay was shivering and confused. I carried her to the car and hugged her all the way back to Kevin's house. In the morning there was still no sign of Charlie. It stopped snowing and we looked for tracks. The next day still no leads. I brought Fay home to Sixth Street while Randy hung in at Kevin's. I was astounded when Charlie turned up four days later at a Sunoco station six miles down the highway. Randy wasn't surprised. Charlie was on his way back to New York City when he ran out of gas. The station attendant called the SPCA, who picked up the exhausted traveler.

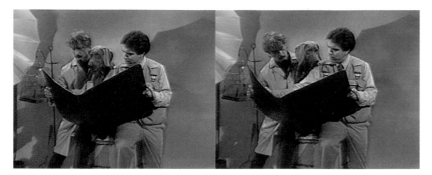

Fay's cameo appearance in
The World of Photography, 1986

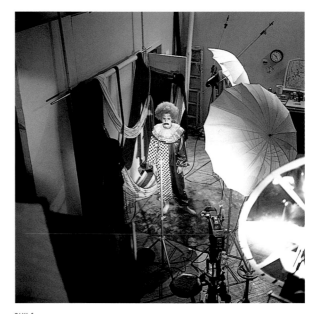

Still from
The World of Photography, 1986

It was hard not taking Fay's picture but

I solemnly swore not to. She was attractive—
more elegant than Man Ray. I looked at her
admiringly but I didn't take her picture. The
memory of Man Ray was still pulling me away
from that. What do you do with a hunting
dog if you don't hunt? You keep them busy.
You play ball. Fay kept her eyes on me as
I worked, drawing, painting, photographing
people, places, and things. She watched me as
I typed. I was working on a script for a thirty-
minute video, *The World of Photography,*
with artist Mike Smith. A commission by *Alive
from off Center,* an experimental TV series
out of Minneapolis. Our piece was to be a
satire on professional photo jargon and
accessories. Darkroom tips, compositional
rules, equipment needs, dress code (Epaulet
shirts with lots of pockets). I wrote in a part
for Fay, a little cameo. It was a big mistake.
The studio was insufferably hot. There were
gaffers and best boys all over the set clomp-
ing sand bags, tripping over metal light stands,
and yelling things like "cut." Fay panted her
way through the part.

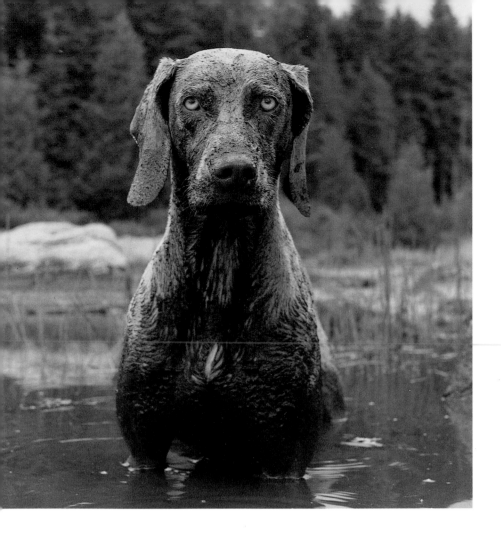

Fay went back to just being a dog, a job

she was very good at. We went to the park.
We took weekend trips to the country. At
nine months she was a magnificent physical
specimen. Powerful in her youthful maturity.
Spectators oohed and aahed at her athletic
prowess. In fundamental obedience lessons
she needed almost no repetition, heeling,
sitting, and staying in exemplary fashion.
When I called her to come to me she ran
hard and straight to my side. She seemed
to know all she needed to know. How many
dogs have you known that were this good?
Be honest. Not very many.

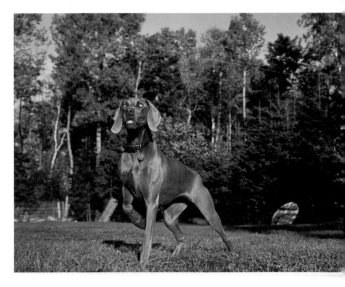

 In June, while the upstate house was
being built, I packed the Buick Skylark with
four months of projects plus Fay and headed
for my place in Maine. We stopped only for
gas. Fay was a good rider, quiet and content
in the backseat. It was a relief to get her

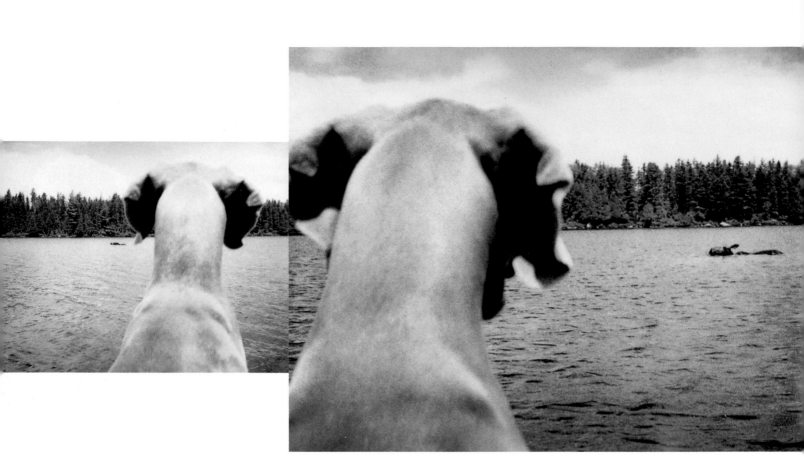

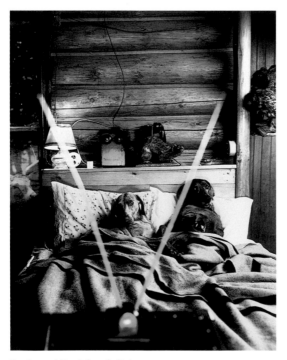

Man Ray and Mrs. Lubner in Bed,
1981

out of the city and into a place I was familiar with. The town where you get groceries is five miles away down a dirt road. I stocked up and bunkered in. Nothing bad happens in Maine—a real Hardy Boys setting. The villains steal firewood or ride atv's on private property or fish where they should not. Sometimes you encounter a grumpy ornery person who acts suspicious or who is suspicious.

What is there to do in Maine? You can read books and magazines. Paint. Draw. Take pictures. Fish. Hike. Listen to the loons. If you have a retriever-type dog you can play my favorite game, dog baseball. It's what we did with my sister Pam's ten-year-old weimaraner named Leibe almost every afternoon. Pam lived in the house next door with her husband Stan and her orange cat

that Leibe tolerated but that obsessed Fay. Leibe had been in one photo of mine when she was four, quite a well-known one: *Man Ray and Mrs. Lubner in Bed*, 1981. Man Ray was about six years older and they were as different as two fish in a kettle. Unlike Man Ray, Leibe was high-strung and didn't take to being photographed. The big flash from the strobe light sent her into hyperspace.

But she loved the ball and, like Fay, was a fanatical retriever. In dog baseball as played by the Wegmans you need a tennis ball and a bat and a good-sized yard. My sister's backyard is perfect for the game – a wide green lawn bordered by woods and the gravel driveway. Her car makes a good backstop, eliminating the need for a catcher. You can use a stick for a bat. Humans take turns batting and hitting. Three strikes and

you're out and you only get one out, not three. If a dog catches a fly ball or a grounder without bobbling it you're out. There are no doubles, triples, or homers. All hits are singles. There is no score. We play until dusk when the bats swoop down from the eaves of my sister's house and drive her inside in terror. What else did we do in Maine that summer? I didn't take many photos. I only remember when there is a picture.

Bill and Fay, Maine, Fall, 1986
Photo: Chris Schiavo

I usually wait until fall to photograph. It's cooler. There aren't many bugs. In mid-September the leaves of the birch and maple begin to change color. One memorable fall I had photographed Man Ray standing in a shady lane in the woods covered in leaves that I had taped on him.

So that September I packed my camera equipment and some props — one of which was a Wonder Woman costume — and went for a hike with Fay down an old logging road. I can hardly walk without a dog. I list. I thought I might photograph the costume propped up somewhere in the woods. We reached a partially washed-out bridge spanning a small brook and I began contemplating the site. Fay looked on as I fiddled with the costume. I tried placing it in a short spruce tree but the prickly needles annoyed me and the costume kept tumbling down. The dumb thing was limp and uncooperative. I looked up and saw Fay on the bridge observing me. I called her down to me and in a flash she was there. Guiding her onto a mossy rock, I got her to sit and told her to stay. Then I broke my solemn vow. I took her picture.

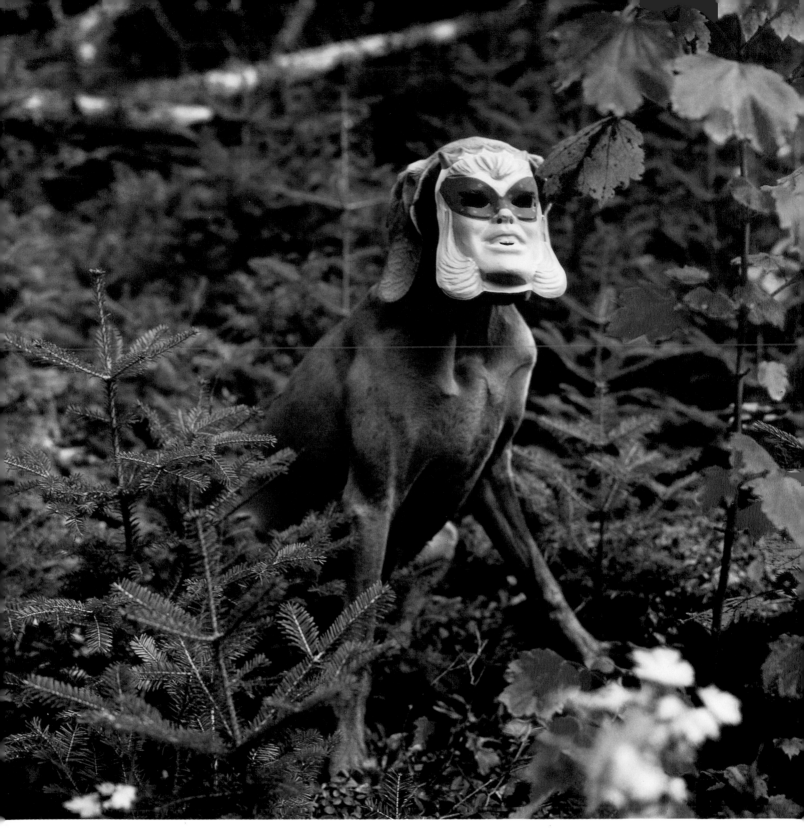

Wonder Woman,
1986

Stills from **Dog Baseball,**
1986

Fay and I got back to New York in October just in time for the World Series. The Red Sox and the Mets. Not that I am a big baseball fan. Hockey is my sport. I played center on my high school team and almost didn't go to art school because they didn't have hockey, only basketball. Basketball is probably my worst sport. I don't play team sports anymore. Once in a while I'll go to a game if somebody gives me tickets. Usually I watch on TV. The 1986 world series was pretty nauseating for Red Sox fans. So it was a timely distraction that *Saturday Night Live*, which had aired some of my video pieces in the mid-70s, commissioned a short film. I sold them on the idea of dog baseball. My house in upstate New York had just been completed and I was looking for an excuse to go. I knew the perfect location, the big

green field on my neighbor's farm. In a short time I assembled a team of nine dogs, some from the city, some from upstate, all friends of mine and Fay's. I was able to shoot the film in 35mm thanks to the generosity of Michael Schrom, a successful director and cinematographer. He lent me the whole farm, field, film, camera, and one of his cameramen, Mark Blandori. Andrea Beeman, an intern from the NYU art department, as well as all the dogs' owners were called upon to help. For dogs we had Fay, pitcher; Charlie, catcher; Rama, third base. Also taking the field were Tuna, Sam, Chipper, Molly, Maps, and Leibe, who was flown in (on camera) from Maine in a Cessna by Rangeley pilot Steve Bean. Once I set up the bases and introduced the players' "up close and personal" style, it was only a matter of keeping the nine dogs in their respective positions. No mean feat.

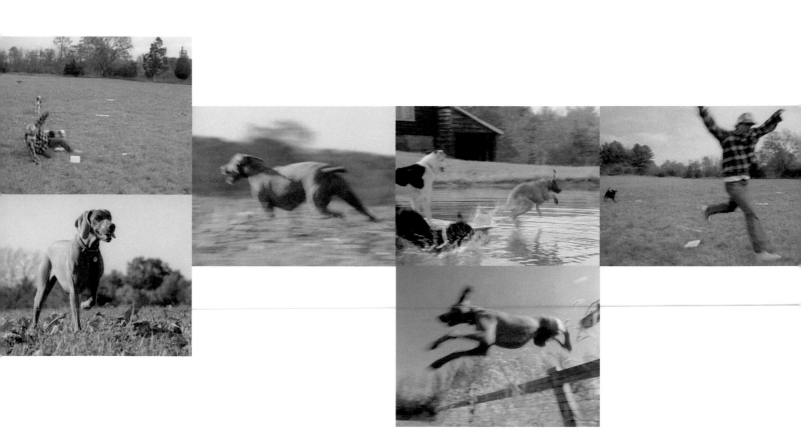

Surprisingly, things proceeded smoothly, except for third baseman Rama who in spite of insistent coaching kept trotting home. Time after time after time. Suddenly Rama looked out and saw all the other dogs sitting and staying in their positions. Oh, I get it. You could almost see the light in his brain. And then it was "play ball." I was up first. After a couple of balls and two strikes, I connected, launching a towering fly and sending all dogs in hot pursuit, except for Maps, who was down at the pond sniffing plankton or something. I rounded the bases. A homer. One to nothing. A group of spectators (the dog owners) groaned in disappointment. I'm up again. Another magnificent blast to which Fay gave chase, soaring spectacularly over a high garden fence down to the dock and

leaping into the water with a great splash. I circled the bases as the dogs romped in disarray. Two to nothing. Game over. I win!

But not before weeks of intense film editing. I wound up with several reels of crazy wide-angle footage to work with, not what I had expected. I had envisioned something elegant, intense, hypnotic like a weimaraner. I had to rethink the whole thing. In a panic of intense cutting and pasting with editor Shelley Silver and my newfound assistant Andrea Beeman, we came up with three and a half minutes of loopy deadpan farm ball. Andrea's quiet presence discovered during this project became an asset and I began to call on her more and more. I think of the film as Fay's true debut. All the dogs were great, but she was the star.

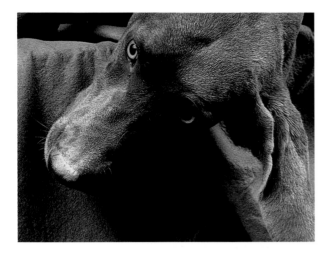

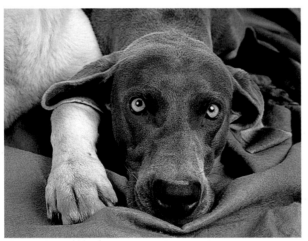

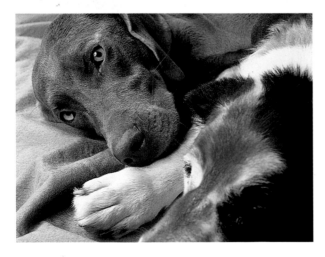

Fay's public photographic debut came in
the form of ten large-scale photo-display
light boxes installed in Penn Station, a
commission from New York City's Public
Art Fund. After applying brightly colored
theatrical face paint to Fay and Charlie
I photographed them at Sixth Street in
leisurely repose. For the project I used a
6 x 7 format camera and had them printed
as 40" x 60" cibachrome transparencies.
Fay's seductive presence pervaded the series.
"Is this for *Playboy?*" one passerby asked.

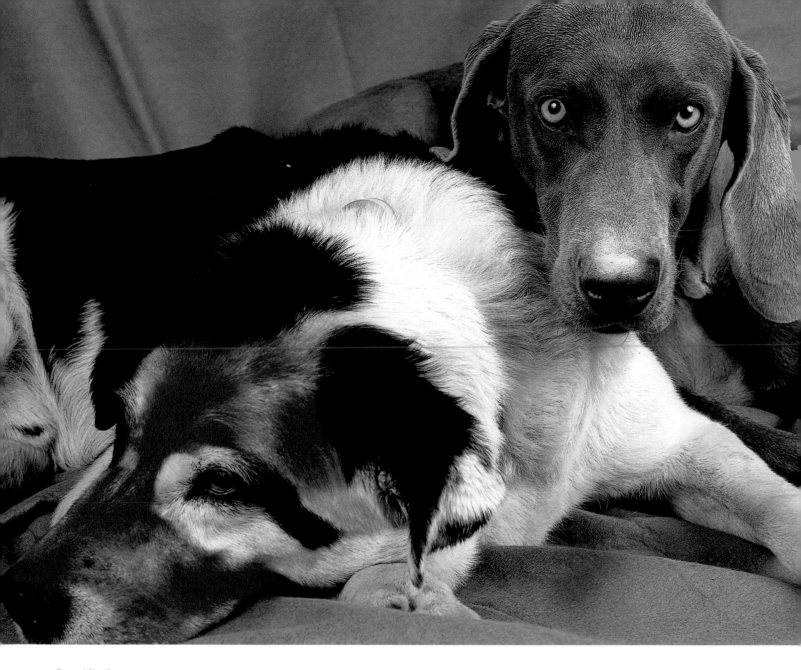

Fay and Charlie,
1986
Installation at Penn Station,
New York

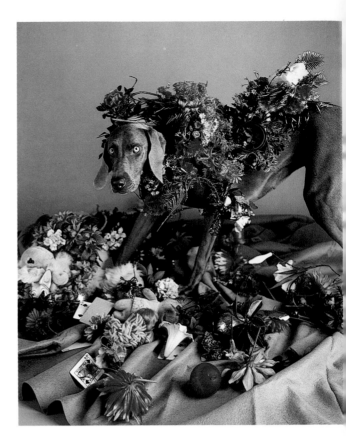

My first experience in the Polaroid 20 x 24 studio with Fay was a little spooky, haunted by the ghost of Man Ray. The studio was about twelve blocks from my house on Sixth Street. I stuffed a few props in a duffel bag, put Fay on a leash, and headed across town. Passersby waved and cheered. There was joy in lower Manhattan once again. Except in Fay's eyes as she hyperventilated her way through the Bowery. Man Ray never slunk through town. Fay, this elegant creature, cowered.

The Polaroid studio was on the sixth floor. I fretted about Fay in the elevator. Would she convulse, bite someone, barf all over the place? I waited until we were alone before boarding and Fay got on without a fuss. As the automatic doors closed she leaned against my knees, comforted by the proximity of the four little walls. Down the hall was the 20 x 24 studio, a space dominated by the large format Polaroid camera. Invented by Polaroid engineers in the late '70s, the camera was designed to take

Rising, 1987

Garden, 1982

actual-size portraits. I was part of the first wave of artists invited to use it. Photographer John Reuter runs the studio and has been working with me since 1980. John was there for Man Ray's last picture and he was there for Fay's first. What better way to begin than where I left off.

With Fay in the studio, in the prime of youth, I couldn't help but notice differences between her and Man Ray. The young Man Ray was brainy, full of games, a real character. As he got older, as we continued our work, his stature grew and he commanded the page with a presence even I couldn't diminish. Whether covered in fabric, painted with makeup, dusted with flour, wrapped in tinsel, flippered, horned, or turned upside down, Ray was still Ray. Still the man. Here was Fay, watching me from the couch with

those mysterious eyes. Where was Fay? Was she hiding? What a slippery color she was. Man Ray soaked up light, his blue-gray coat appeared almost black in photos. Fay's coat absorbed light and reflected it back into a new color. On the dark-blue studio couch, it appeared purple-brown. That morning against set paper #46 pink, her soft warm cinnamon coat became infused with dusty rose. Against set paper #2 thunder gray, her fur cooled to gray. Fay Ray the chameleon. Fay liked being attended to, blanketed with props. John Reuter was kept busier than usual changing filters, trying to adapt to the shifting color balance.

"Not bad," said John, commenting on the day's results. "Not good," I said. "See you tomorrow." I felt old. I *was* old (forty-three). I had a stiff neck.

Double Profile,
1980

I came back the next day and set up a shot posing Fay with Andrea. There was something about their eyes—the light, the clarity, and something more inside. Fay and Andrea, two young and pretty girls. To add an anthropomorphic touch to Fay's girlishness I fixed false eyelashes above her eyelids. An unnecessary supplement in retrospect. More interesting was that she let me glue them on so close to her eyes. She didn't bat an eyelash. The photo that rolled out of the camera seventy seconds later made me think of the pictures I had taken nine years earlier at the Polaroid 20 x 24 studio in Boston with Man Ray and Hester Laddy. Hester was one of those people who needed a camera on her at all times. A performance artist and former student of mine from a 1978 Cal State Long Beach class, the camera loved her. The manifesto-wrecking *Double Profile* was stunning, more profound than I ever could have anticipated. I had never taken a photo so unabashedly beautiful and it embarrassed me. I can't verbalize its meaning. Something took place between them. Hester had the uncanny ability to assume Man Ray's physical language. In a quieter way Andrea adopted Fay's personality as she settled into frame with her. With the picture you get the picture.

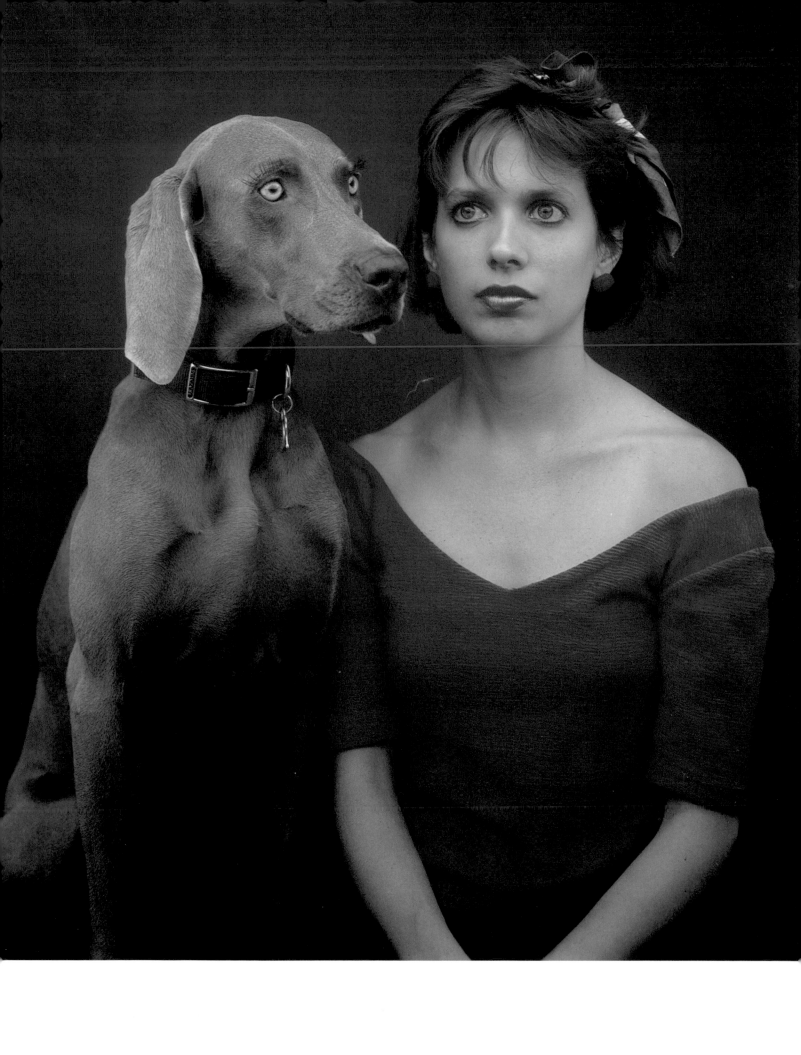

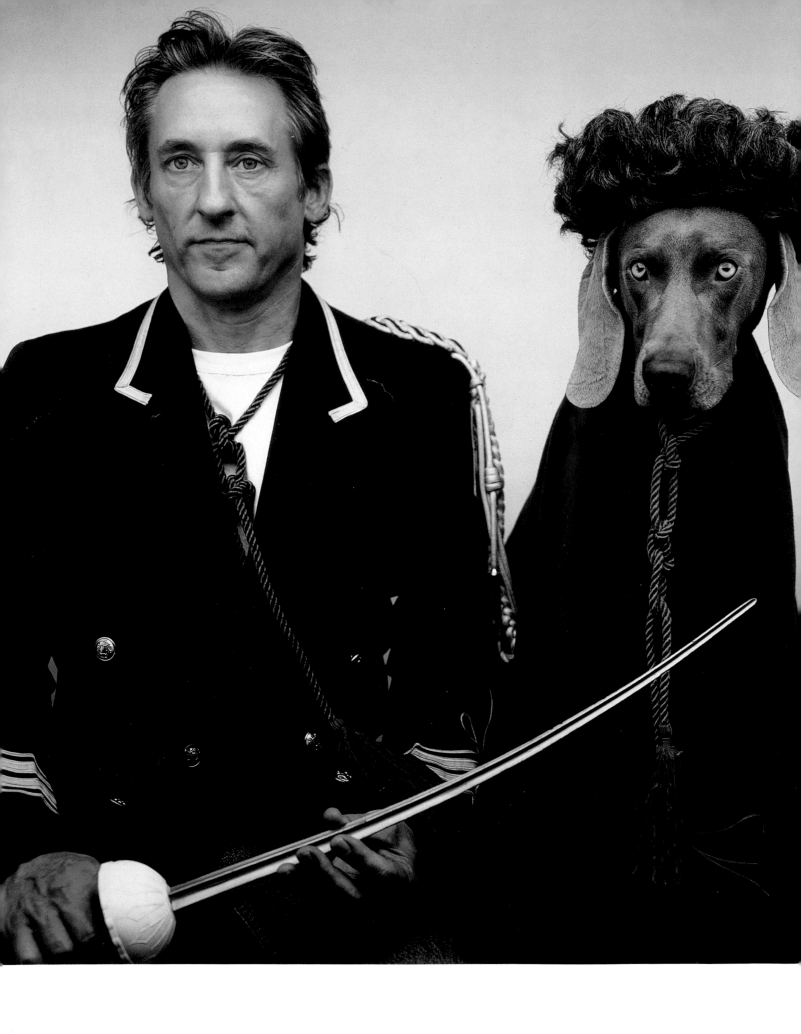

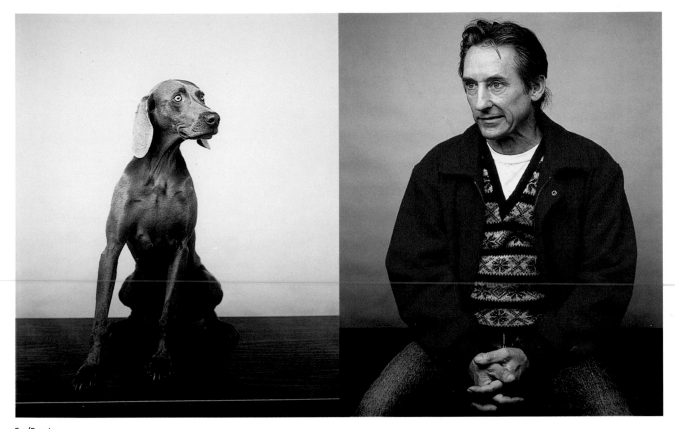

Fay/Ruscha,
1987

Later that afternoon one of my heroes, the Los Angeles artist Ed Ruscha (Rew Shay), popped in. A visit the previous evening had triggered an idea. Noticing an aura of similarity between him and Fay, a certain pale gray, blond, light blueness about them, I posed Ruscha, the master of droll, opposite Fay in consideration of a two-panel piece. Fay in the left panel looked over at Ed who in the right panel mimicked her expression, returning her gaze. Unlike the Fay and Andrea photo and *Double Profile* with Hester and Man Ray, Fay Ray and Ruscha appeared separately, making contact through their lines of sight. Droll meets drool. Encouraged by the success of the shot and gaining courage to boldly move forward, I set up another shot with Ed and Fay, using some props and costumes I had brought along. Fay let me put a wig on her and Ed wore a band uniform. A prince and princess theme developed, quite a handsome couple, I thought. Again images of Man Ray drifted into consciousness and I remembered a picture that never happened. Man Ray with John Belushi. Too bad. It would have been great. Man Ray had the assertiveness and the bulk to hold up to him. Belushi wanted to do it. I was going to. We never did. I thanked Ed, Andrea, Fay Ray, and John Reuter and walked Fay home. Man Ray came too.

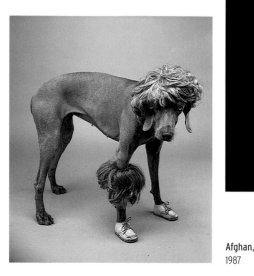

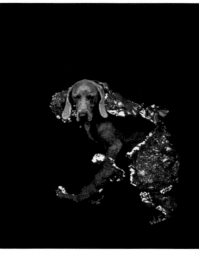

Hatched,
1987

Afghan,
1987

The following week Fay and I went back to the studio. I proceeded to wrap her in red aluminum foil. Dogs like to be covered, I believe. It quiets them. Once I had wrapped Man Ray from head to toe to tail in gold Christmas garland. Initially it surprised me how calmly he went along with it. When I thought about it, the act was quite like putting his collar on over and over and over. Fay was behaving similarly. Safe in her cocoon of red foil, she looks like she is hatching. And therefore the title *Hatched*. I think of this as my first true picture of Fay. One that shows her unique personality. Her fragile nature. It has the look of a first. New born.

What to do next? My eyes wandered from Fay to an ironing board standing in the corner, silver, lean, and gray. I looked back at Fay who was also standing looking silver, lean, and gray. I picked up Fay and placed her in a standing position on the ironing board in the middle of the set paper – a background of cool medium gray. John moved the lights into place and readied the camera. I quickly took the picture.

The ironing board was pretty wobbly and it vibrated as Fay strained to hold her balance. I took her down immediately. Fay was good at balancing and she seemed intent on the struggle but I didn't want her to stress out. After a quick pat on the back and an encouraging word I hefted her back up, this time finding a more serene pose. Reclining on her side emphasizing her beautiful head with its yellow eye – beam of light, Fay looked much more comfortable, poised, even regal. The picture became a favorite of mine. I was struck with the difference between her and Man Ray's balancing ability. With him you don't see the intensity, the struggle for equilibrium. Just the pose. I began to focus on Fay Ray's unique nature.

Another favorite, *Netted*, shows Fay covered in black net on a field of pale yellow, a background color I soon latched on to as particularly right for her. The lines of the net fall perfectly across the pupils of her lovely yellow eyes, not disrupting her vision but perhaps diffracting it slightly. The net in so doing secures both her and her expression. In the following weeks there were more pictures *Afghan, Evolutionary, Roller Rover, Cloud* and *Ladybug*.

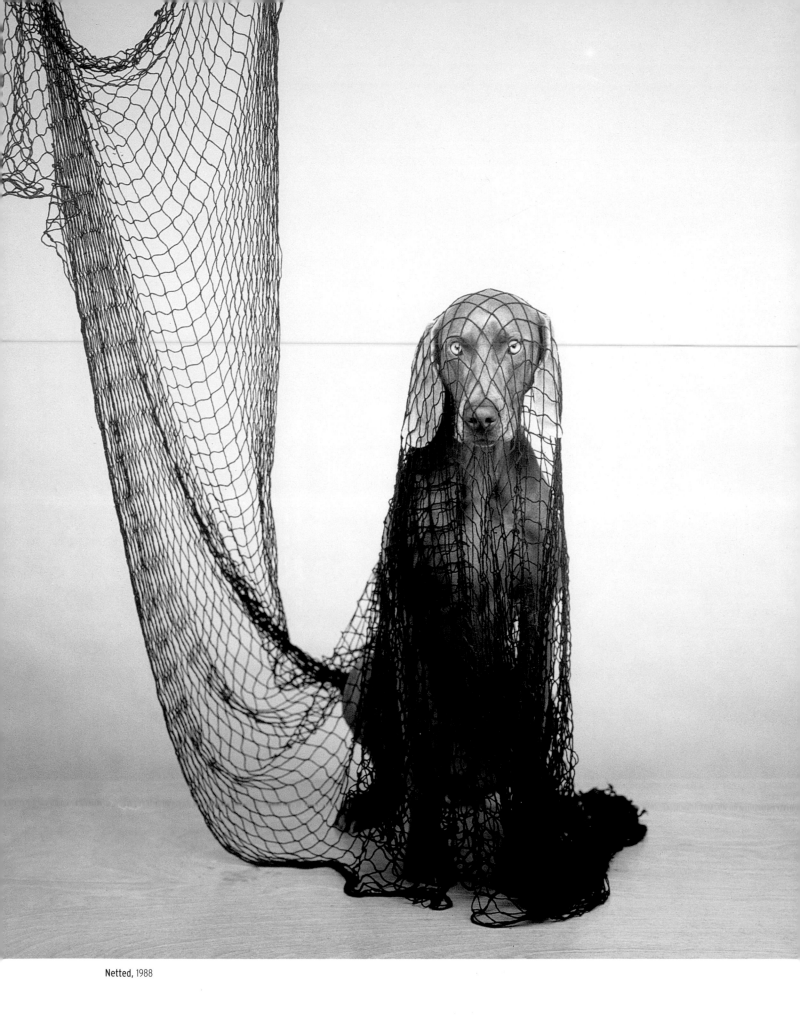

Netted, 1988

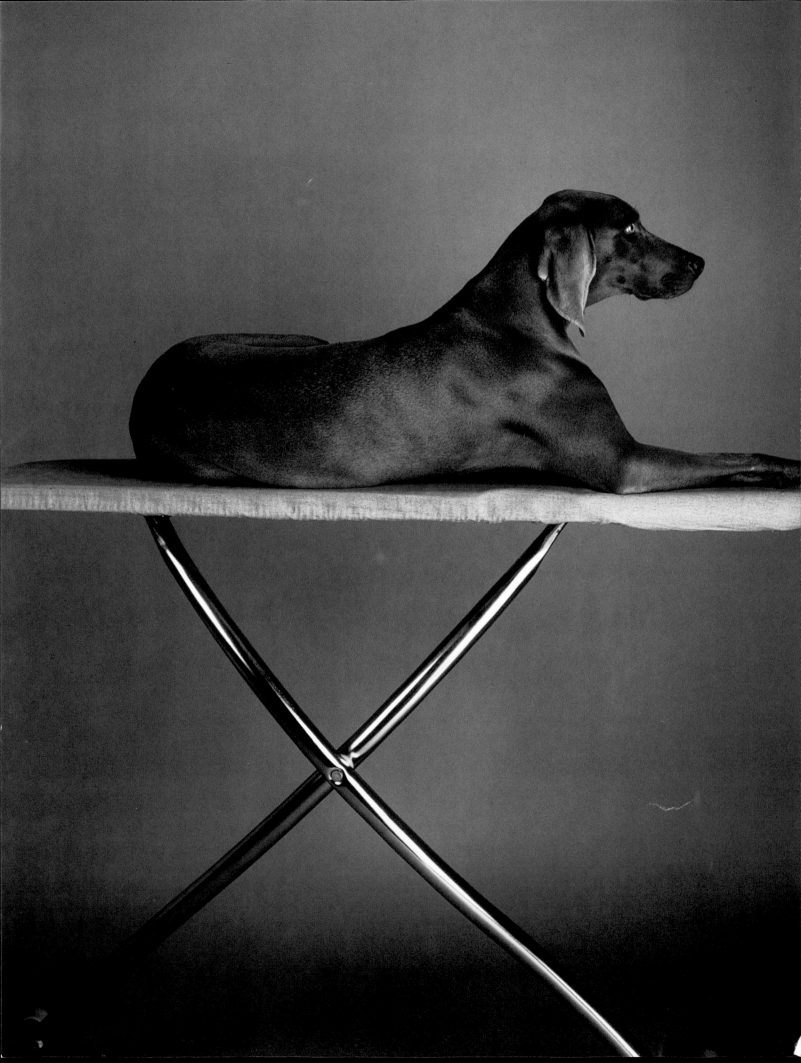

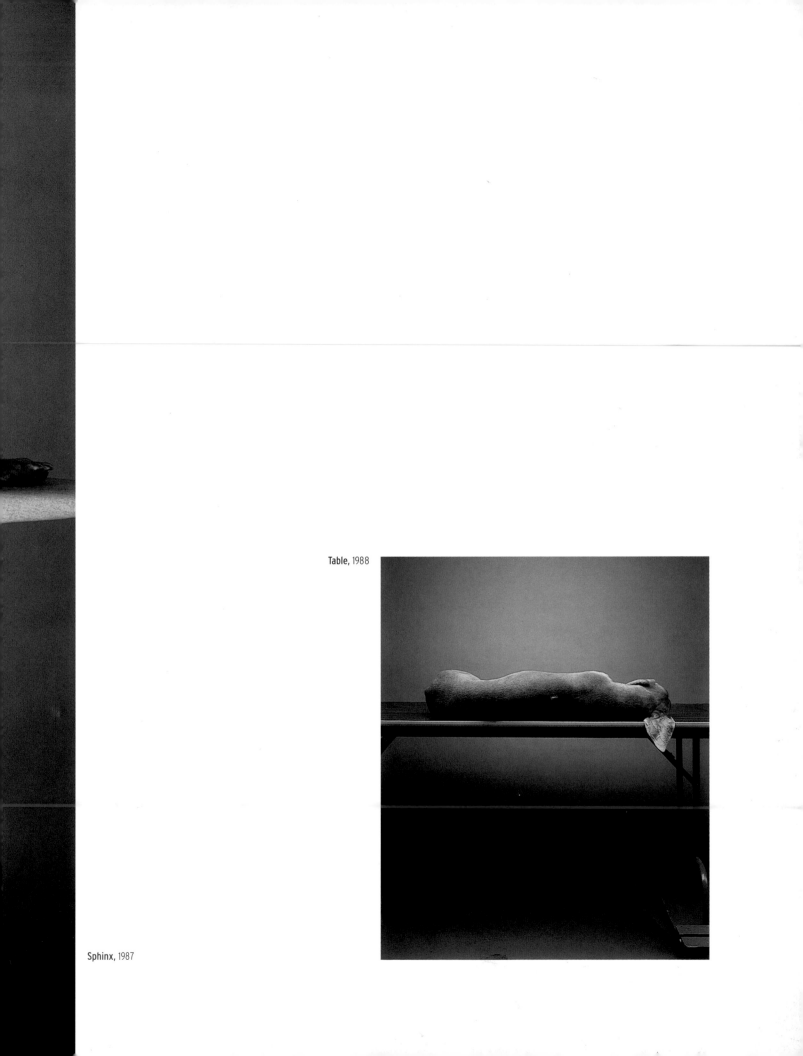

Table, 1988

Sphinx, 1987

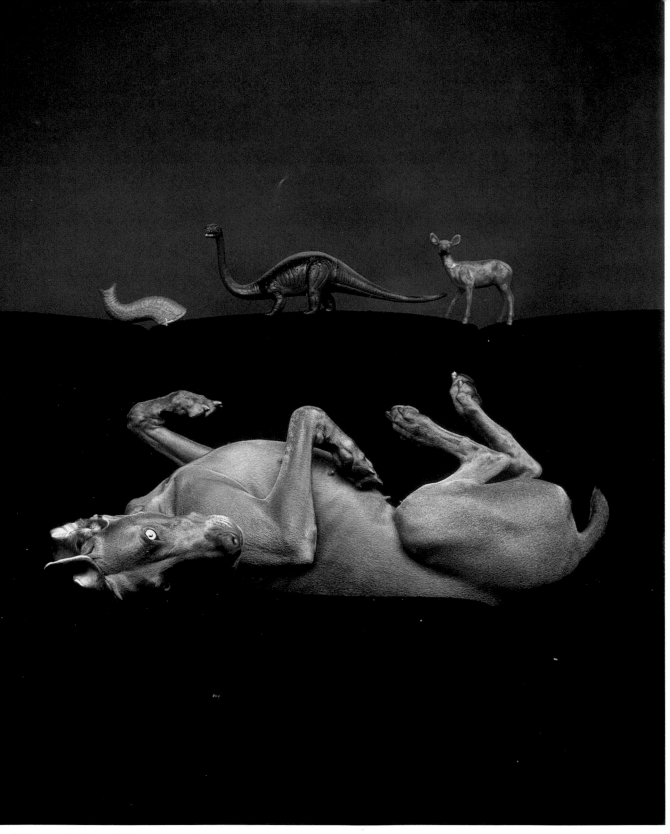

Evolutionary, 1987

Roller Rover, 1987

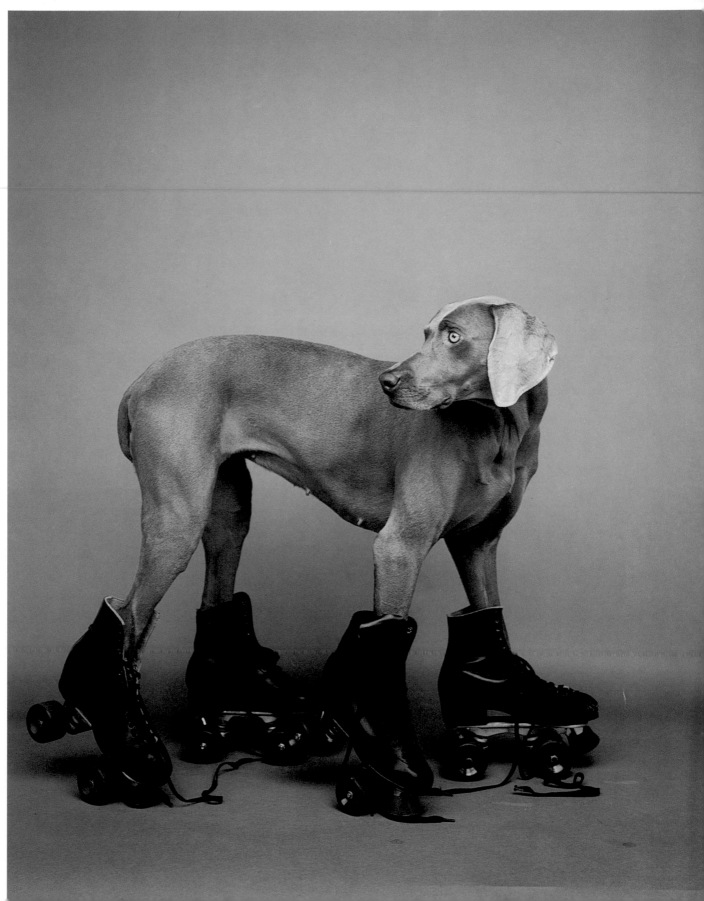

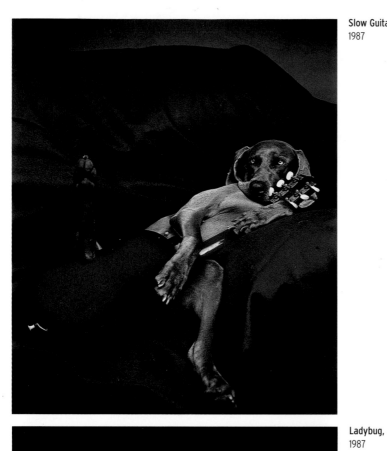

Slow Guitar,
1987

Ladybug,
1987

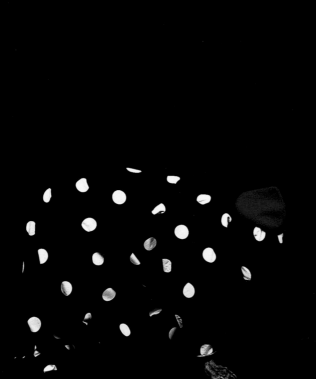

Le Douanier Fay,
1989

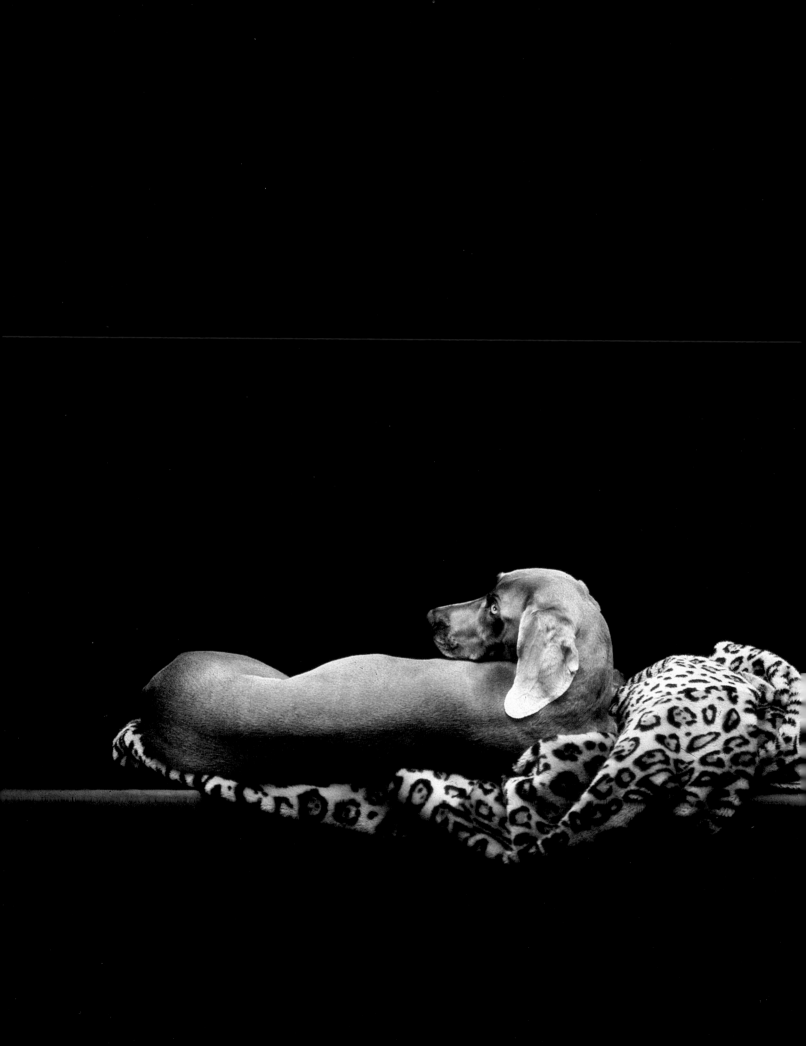

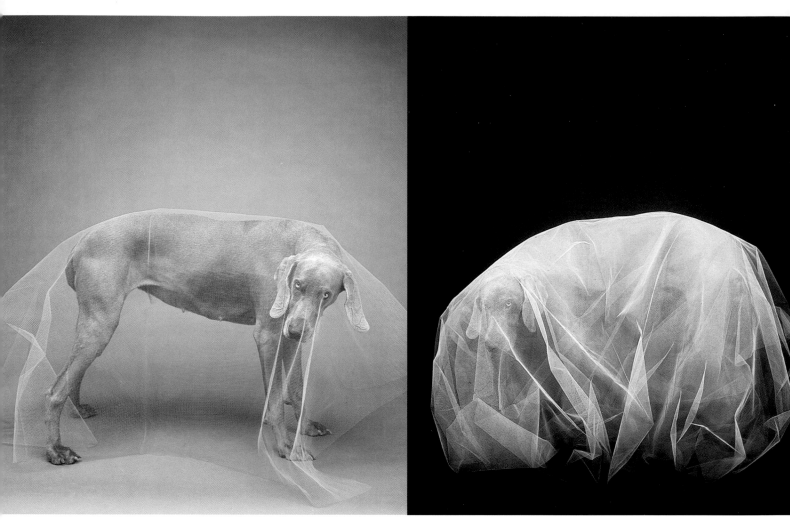

Smoky Speculation, 1989

Severini, 1989

Cloud, 1988

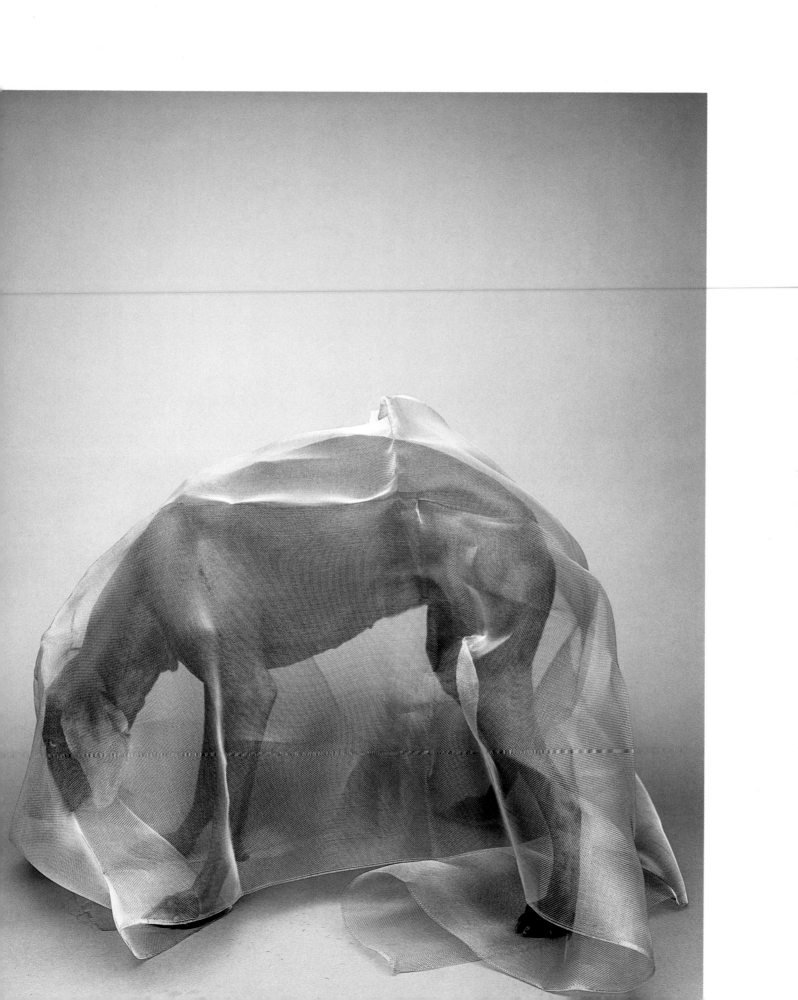

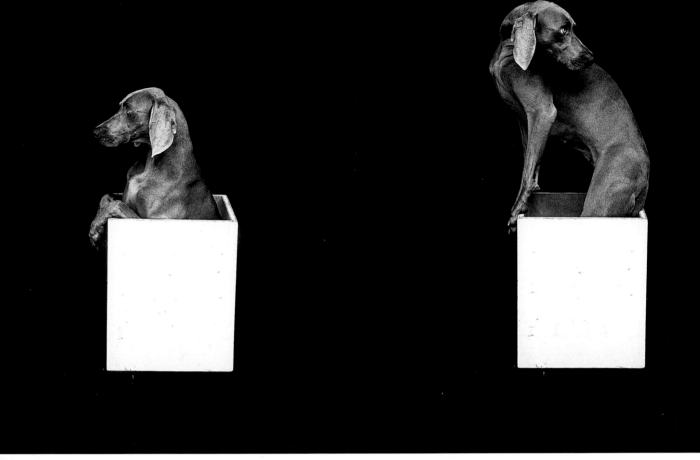

I booked the studio for two or three days
a week, skipping a week or two for trips
upstate where I painted and Fay worked on
her pointing and retrieving. As time went on
and Fay got stronger—and braver—our trips
across town became less the event. Before
long I introduced Fay to the box, the garden-
variety eighteen-inch-square white plywood
type you always see in art galleries and
photo studios. Museum basements have a
lot of them. The box I found in the studio
was open on one side. Most dogs instinctively
hop up on a box. They want to, need to be
tall. Fay wanted to go *in* the box. On this
inaugural day she settled into it easily and
without a fuss, her muscular elegance
exquisitely framed and contained. I fidgeted
while John bullied the big camera into

position, focused, added filtration, adjusted
the lights, closed the back, closed the lens,
set the f stop, rolled down the sheet and
advanced the negative. Finally he said
"Ready Bill?" To Fay I asked "Ready Fay?"
She kind of nodded that she was. I took
the picture, snapping the long cable release.
A loud pop and a flash—the powerful
strobes surrounding her fired. She held
her position, relaxing a little, as I went back
to observe John guide the exposure sheet
out from the back of the camera. Then he
cut the exposure away with a razor-sharp
knife, ferrying it to a work table. After seventy
seconds the timer went off signaling time
to peel back and discard the negative to
reveal the picture. It was a good one. On the
average only one in ten is. John pinned it up.

Houdini, 1989

I turned my attention to Fay, who had assumed
an extremely beautiful pose all on her own.
She was standing with her front paws on
the edge as though climbing out of the box.
With the ever-present tennis ball I directed
Fay to look back over her shoulder and I took
the picture. Pow! An explosion of light. Fay's
afterimage burned into my retina. I pinned it
up next to the other. "Pandora," I said, tossing
Fay the ball. A thousand pictures followed.

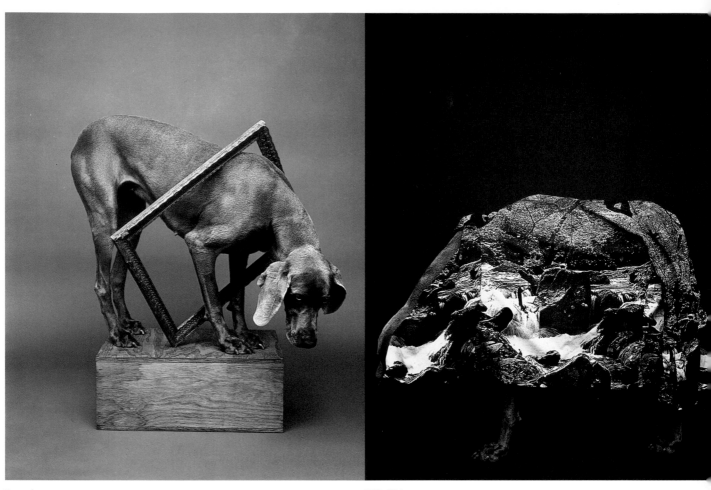

Framed,
1988

White Water,
1988

Coat Hog,
1988

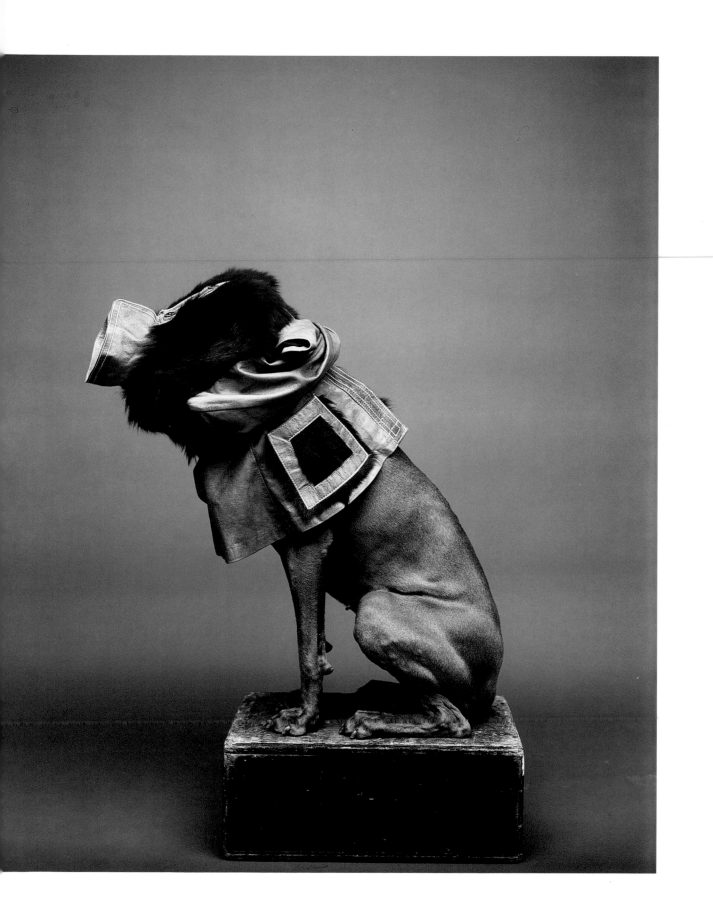

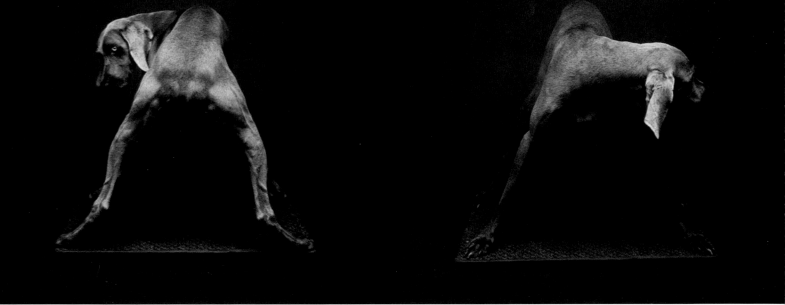

Heads or Tails,
1988

Once I committed to photographing Fay,

there was no turning back. Picture followed
picture followed picture. I never, even for
a second, did not know what to do next.
And it was enjoyable work. Lugging Fay
on and off the set, I discovered new poses
and different angles. She weighed a little
over sixty pounds. Twenty pounds less
than Man Ray. Her body felt warm and
malleable like clay, only furry. Seductively
tactile, she was as lovely to hold as to behold.
I had my hands and eyes full.

And my mind. After working I carried
the images around in my head. Each picture
revealed a new Fay look, imprinting it indelibly
in my consciousness, like a map. Fay sprang
to life through the photographs.

From basic positions: sit, stand, bridge,
lie down, roll over – explored to a degree
with Man Ray – I discovered new ones: the
leg scissors, the standing bowl, the helix,
the narrows, the standing look-back. More
complex ones followed: the fold, the twist,
the tilt, the double helix, and on and on.
As far as Fay was concerned the more
difficult the better. She was bored with
the easy positions. She wanted to impress.

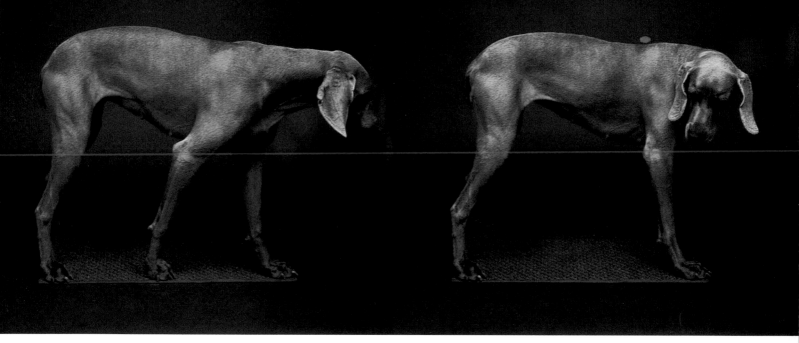

Side by Side,
1988

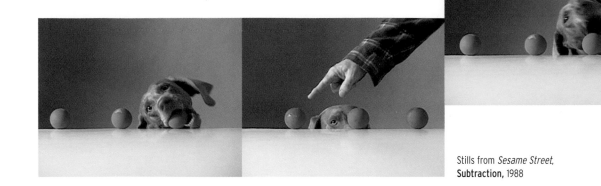

Stills from *Sesame Street,*
Subtraction, 1988

Peter MacGill was interested in showing the new work at the PaceMacGill gallery. In November 1987 a group of pictures was chosen, matted, framed, and hung. I was a little nervous for Fay. A dog act is a hard one to follow even for another dog. The show was a success from all perspectives. Critics critiqued, collectors collected, museum curators curated. I started getting phone calls.

One call was from Arlene Sherman, a producer for *Sesame Street.* Would I be interested in making short video segments for the show? Do you mean with the Muppets? No, not the Muppets. A big part of Arlene's job is to seek out filmmakers and performers outside the Henson circle who she thinks can intersect with the main street. A fan of my early '70s video, Arlene thought the simplicity and directness of that work might lend itself in work for children. I hadn't made a video in ten years and

was clueless about children. Arlene brought over a guidebook the size of the Manhattan phone book showing just what type of thing you could and couldn't do. Perusing the vast range of topics I got the feeling I had been there before. Arlene, seeing I was intrigued, prodded "What about it?" "Maybe I could try something," I said. "You can do anything (almost) that you want," said Arlene. Fay nosed her

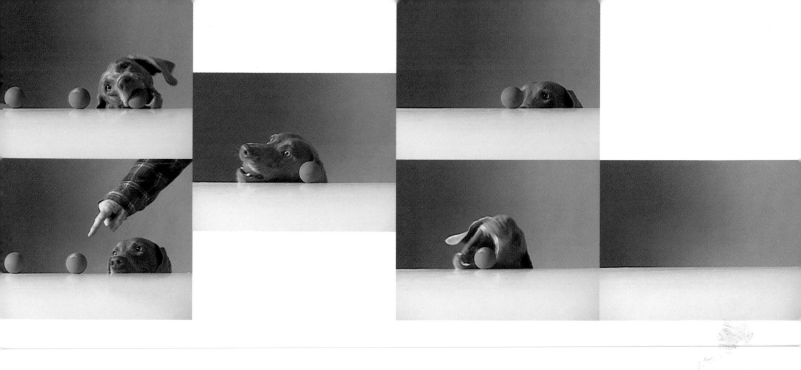

way into the conversation. We both stopped to look at her. What about it, Fay? Fay picked up the ball and dropped it in Arlene's hand. She tossed it back to Fay. Then Fay rolled it to me. I got an idea.

I made several short video pieces of Fay with a blue rubber ball, illustrating simple examples of addition and subtraction. Fay snatched the balls off a white tabletop one at a time for subtraction. I reversed the direction of the footage, causing Fay to appear to place the balls on the tabletop with uncanny precision to illustrate addition. The blue balls gave her something to focus on. Michael Petshaft directed lighting, camera, and sound with extra special care not to trip over any cords, lightstands, anything that might send Fay flying off the set. With Andrea's help production fuss was kept to a minimum and the shoot went smoothly. My first studio video since 1978, the work gave me a good feeling. The minimal set consisted of a wooden table against a background of light gray set paper. In postproduction I provided the narration over rather straightforward edits. "One ball plus two balls is three balls. One two three. Take away two equals one."

Other works I made for *Sesame Street* that year were unashamedly stolen from my own video and photo work of the early '70s, using Fay rather than Man Ray to demonstrate comparative concepts like on/off, near/far, in/out. I also managed to mine the later Polaroid works with Man Ray dressed as other animals. This time Fay was the frog. My green velour hooded bathrobe and antiquated swim fins became useful for the first time. The simple ball pieces were more effective. Fay's clean clear looks made for clean clear memorable video. Fay's presence was a little scary, a lot scarier than the Cookie Monster's. But children liked her and they liked her name. "Fay." *Sesame Street* rates the retention and attention span of the children watching the show. Fay's rating was among the highest. I continued working with *Sesame Street*, producing at least a few minutes every year except 1991 when we made station IDs for the Nickelodeon network. It was a whole new audience for me. In households where there were children between the ages of three and five Fay became a household name.

Working with Fay lifted me out of the artistic malaise from which I had suffered
in between dogs, and I experienced a surprising freedom. My paintings
found new breadth escalating in scale and scope. They began showing up
in important exhibitions – the Whitney Biennial, for example – and critics,
however skeptical, began taking notice. But no matter how busy I became
I always found time to work with Fay in the photo studio. After all, it takes
only one-sixtieth of a second to make a photographic exposure, leaving
ample time for other activities like my hobby – collecting stuff. All kinds
of stuff, potential props. By 1988 I had acquired a considerable heap from
yard sales, flea markets, and the street. I could have opened a store.

A lot of this stuff ended up in the pictures with Fay. Some accompanied,
some adorned, some she stood on. The Polaroid 20 x 24 camera is verti-
cally oriented, which presents certain compositional problems. Not a
problem when photographing people but dogs are vertically challenged.
There are ways to accommodate this, of course, but regardless you have
to address it. So I was always looking for things Fay could stand on.
Chairs, tables, benches, stools, anything to get her up into the frame.
One day I put her on a little rustic pedestal table with a round top. She
appeared as tall as me. Rummaging around the room for props I came
across an odd-looking long beige dress and jacket still on the hanger. The
ensemble, hanger and all, went up to Fay and slipped itself over her head.
Stunning. She looked amazing – strange and kind of scary. Her round
yellow eyes yearned for something. I found the tennis ball and tossed it
to her, snapping the picture just before she caught it.

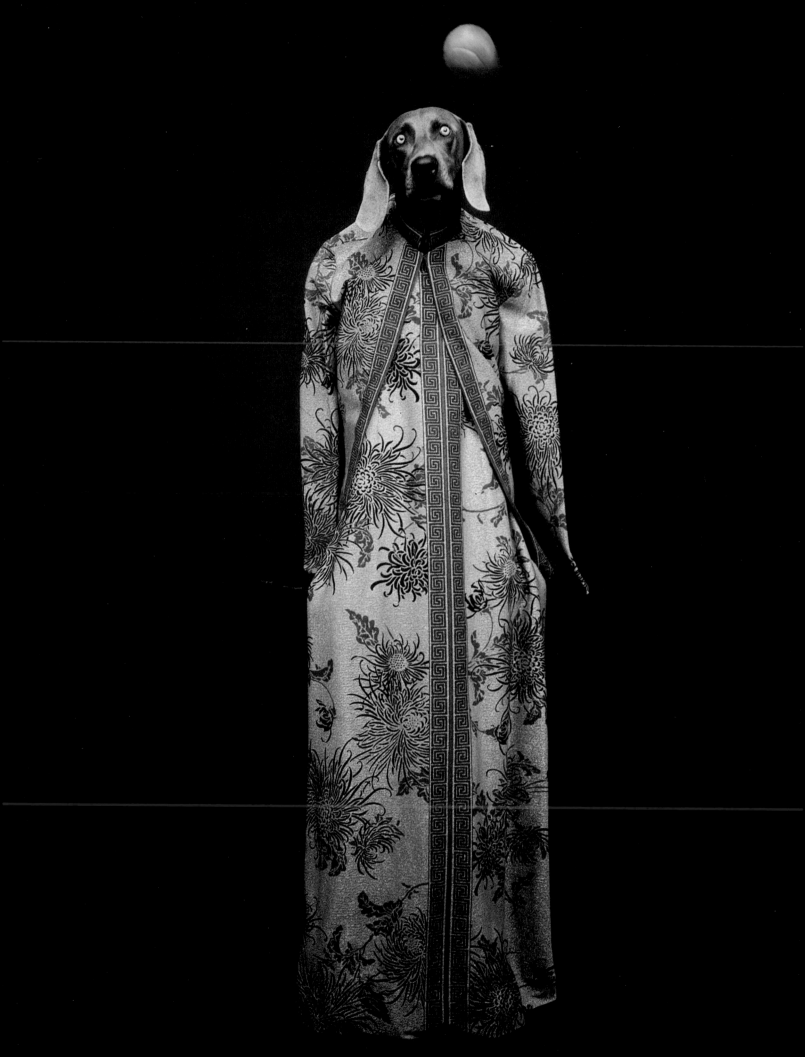

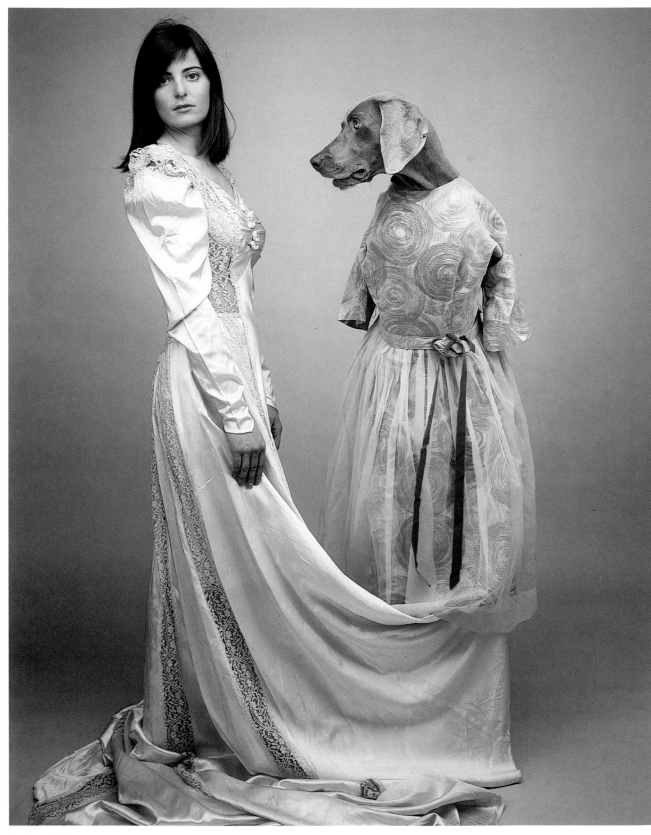

Arm Envy, 1989

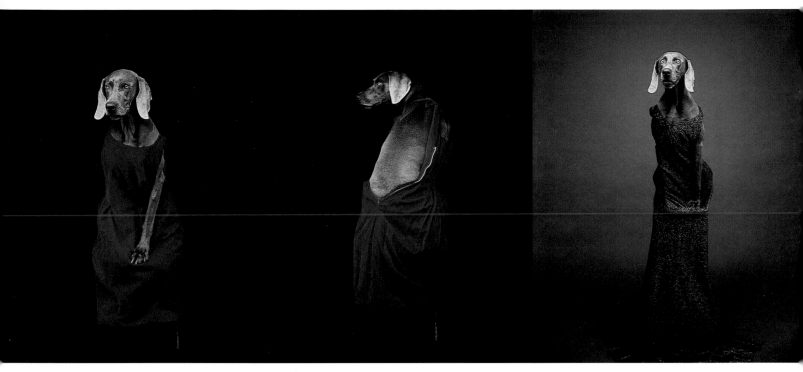

Red dress, 1989 Backless, 1989 Figure, 1989

I started looking for dresses, shopping for them in yard sales and thrift stores. Big dressy dresses were sought, long in the hem. They hid more. "They're for my dog," I'd explain. I only dressed Fay in the studio. As she sat on a wooden stool I would slip the garment over her narrow shoulders clipping it together behind her neck. The arching hump of her back in that seated position really imposed the limits of the illusion. From the side she looked hunched, like a right triangle with a hound's head. Only when photographed straight on is the illusion of anthropomorphism convincing. And then there were her arms. She had none. I was particularly struck by this problem the first time I posed her in a dress with short sleeves. She looked like an amputee. Alongside the well-dressed figure of my friend Alexandra Edwards, Fay appeared to be in awe of Alexandra's arms. Fay's look and the picture's title, *Arm Envy*, saved this photo but the matter was still unresolved. One day Andrea stood behind Fay to adjust her dress and she gestured out to me with her hand. Her long human arm appeared as Fay's. The illusion startled me. I asked Andrea to duck down, extend her arms, and try out different hand gestures. When I saw it come together I called Fay to attention and took the picture. A miracle. Kind of creepy. Fay was part human. I thought of cartoons and mythology, superheroes, and Egyptian gods.

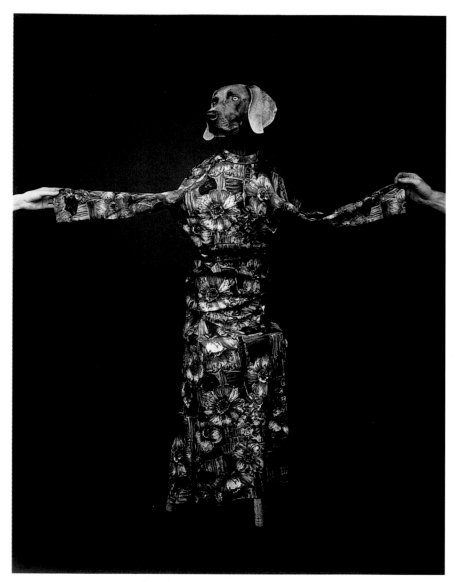

Hands, 1988

Armless, 1989

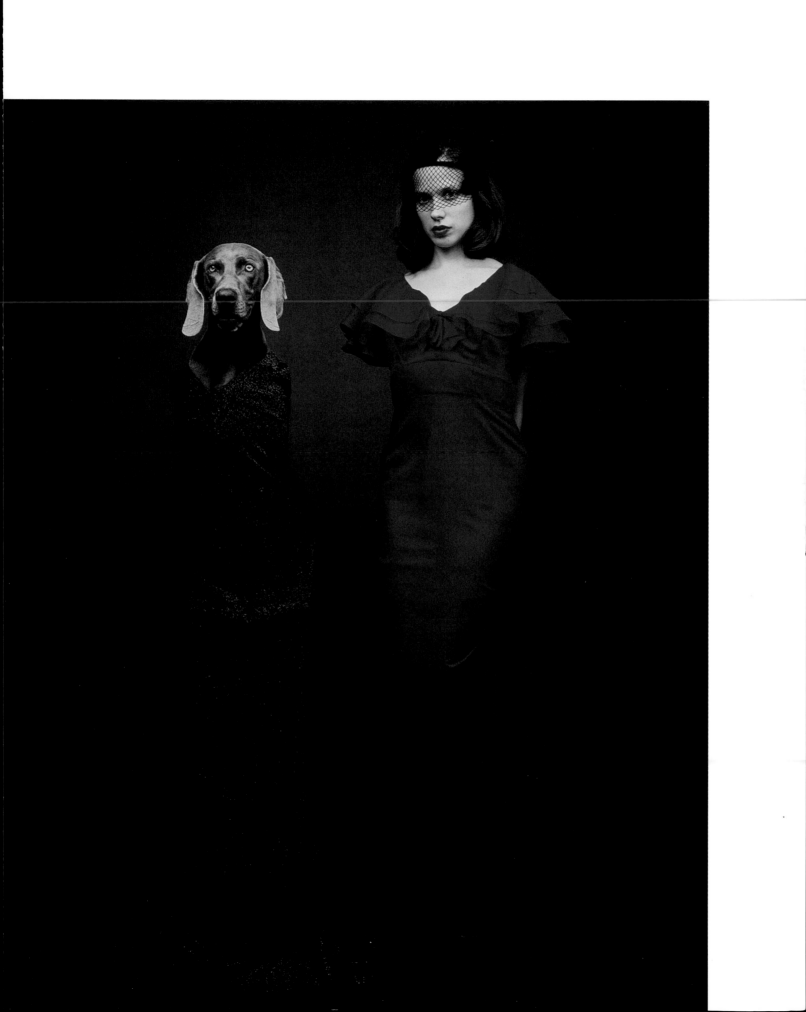

Shiva, 1994

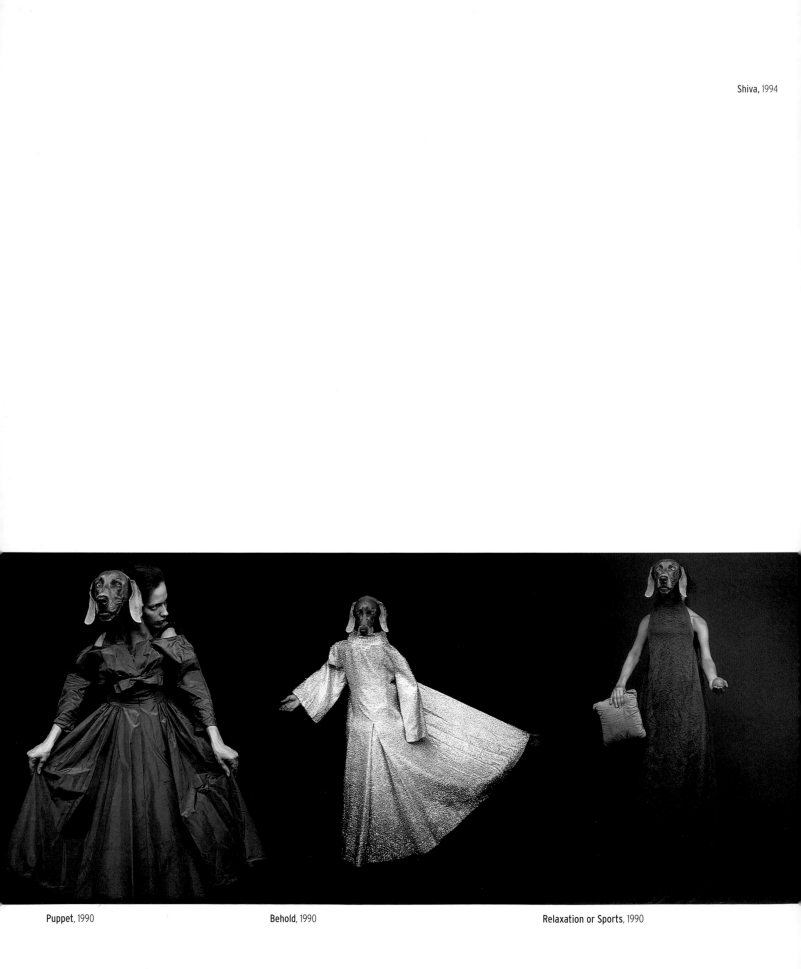

Puppet, 1990

Behold, 1990

Relaxation or Sports, 1990

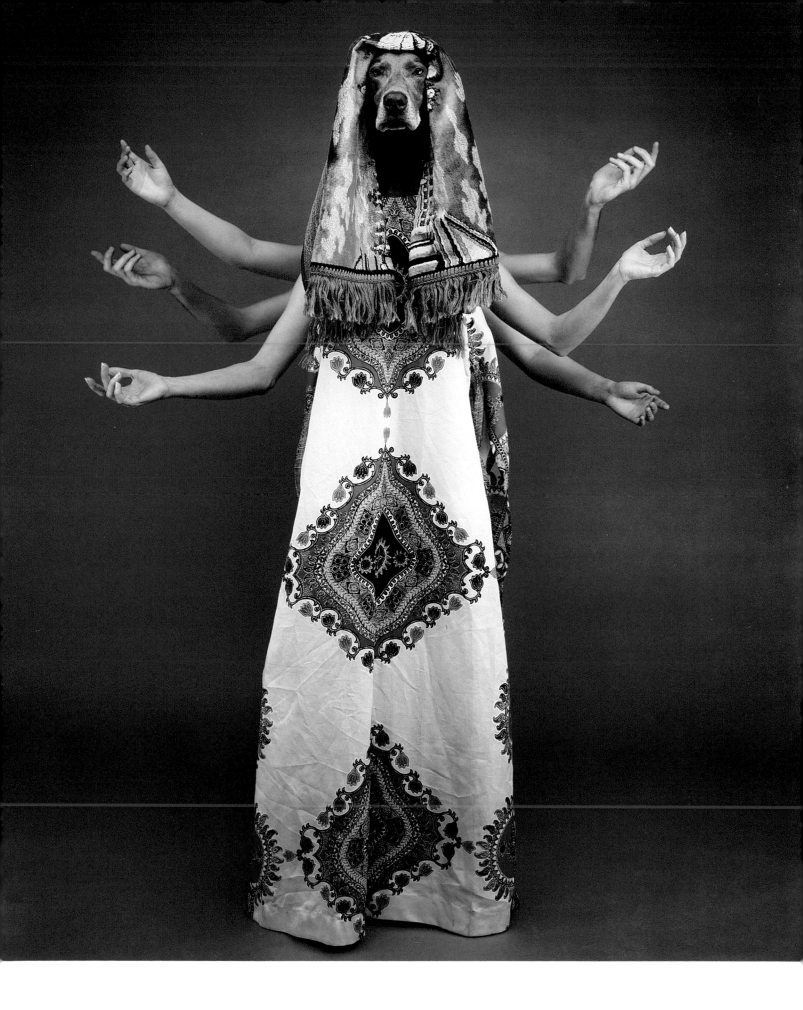

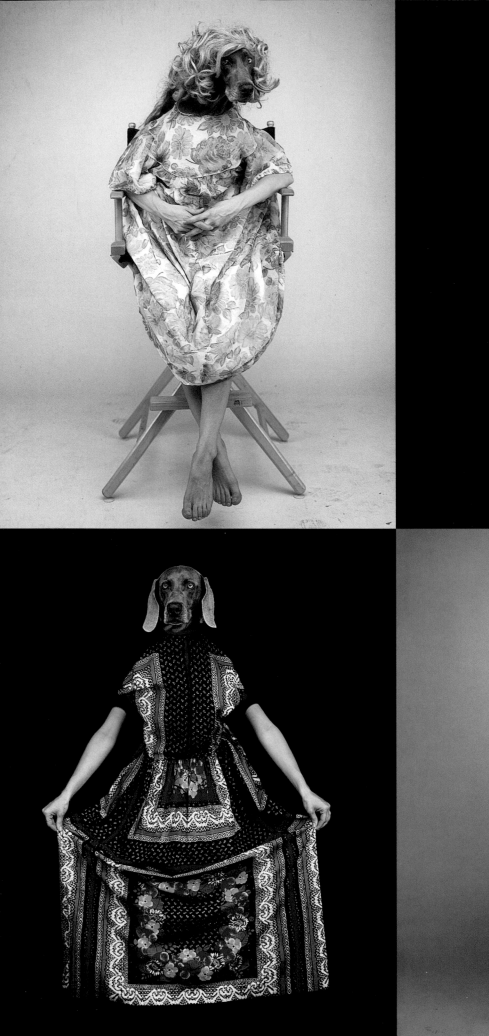
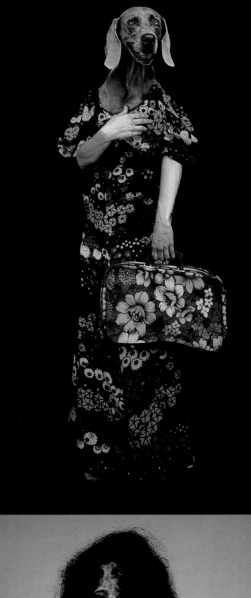
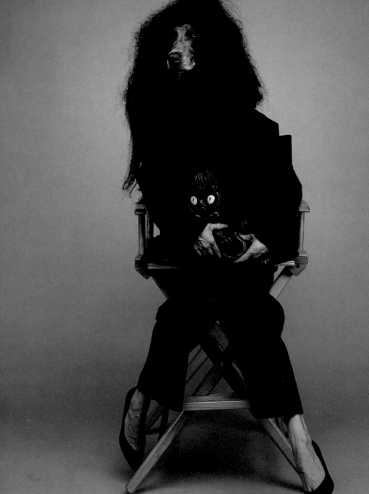

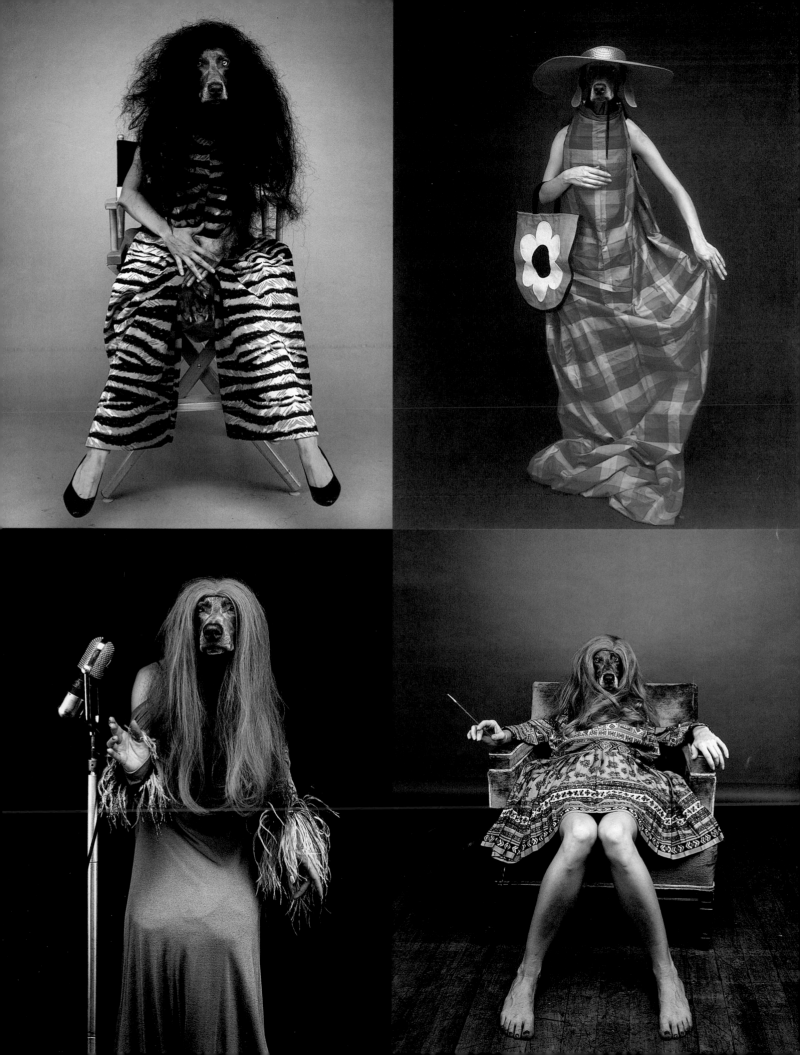

I see a lot of photographs of dogs in hats and sunglasses. Cute pictures. People started sending them to me years ago and now I have quite a few, perhaps a zillion. I am known by many as the guy who dresses up his dog. Guilty. But that was only a recent development with Fay, representing only a fraction of my work. In the selection of props for Man Ray I steered clear of these articles, rarely dressing him in human clothes. It never seemed right. Instead I transformed him into other animals, an elephant, a frog, an Airedale, using found props and compositional devices – a sock, swim fins, a Ping-Pong ball cut in half, tinsel wrapped a certain way. Outside the studio I never went about dressing the dogs for my own amusement. It's not done as a joke in a spontaneous moment of whimsy. Not that dogs mind it, mind you. They will go along with just about anything you do as long as it keeps them in the game. Don't laugh at them, don't confuse them or hurt their feelings. They *will* get embarrassed. Studio manners were something I became very conscious of while working with Fay due to her fragile and sensitive nature. I found it helped the situation to shift the focus away from her and on to the task of the moment – making coffee, loading CDs, unpacking props, choosing backdrops, talking to assistants, setting the stage. When the moment came to direct her she was conditioned, a little subdued, relaxed, ready. On modeling platforms and elevated stands Fay worked at my eye level. An equality of sorts was established, which is the desire of many dogs. I think that's why some dogs jump up on you. Never Fay. She was too polite. With Fay certain protocol was followed in the studio. No tripping on light stands, no crashing and banging on ladders while changing the set paper, no disruptive laughter. Fay wasn't the type of dog you laughed at.

Visitors often dropped in either on Polaroid business or to watch us work. At the sound of the doorbell Fay would whip her head around in wild-eyed alert. Surprisingly, these intrusions rarely became a problem for us, in fact they often came in handy. Fay liked people (and their animal companions). Sometimes I used visitors or their pets (cats were a little risky but the word "cat" was often useful) to get a certain look from Fay. Treats were usually out. Food treats derailed her, causing her to lurch and drool. We needed to start quietly. More often I relied on language, words, and phrases continually revised and renewed. If I used "Do you want to go for a walk?" more than a few times without a walk I'd see her eyes glaze over. The ball almost always worked and it became the all-purpose device of choice in directing her attention. (Dog handlers call it "baiting," a term which gives me the willies.) One day on the set, she was on the tall stool all dressed up and camera ready. I held up the ball, about to toss it to her. Instead of the look of riveting attention she writhed away averting her eyes from the sight of it as if it was Medusa. She was afraid of falling and her inner conflict was enormous. At that point I stopped using the ball when her balance could be compromised.

Previous pages, from upper left to lower right: **Guest,** 1991. **Tourist,** 1989. **Performance Artist,** 1991. **Daisy May,** 1991. **Lap Dog,** 1989. **Cat Person,** 1991. **Joni,** 1995. **Artist Contemplating,** 1994

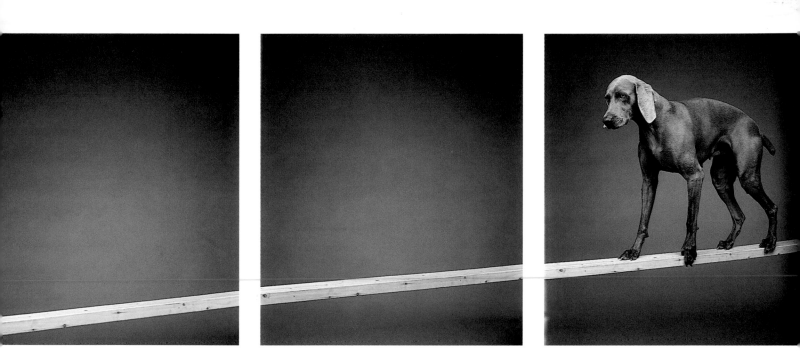

On the Beam, 1989

Fay, I witnessed, truly rooted for a good picture, taking in and giving back the upbeat spirit generated by the process. When there was a bad spell – when photo after photo came out lousy – I had to be careful not to sulk. She'd take it personally. I tried telling her it wasn't her, it was the picture, but that wouldn't suffice. So every picture became a good one. "Good one, Fay."

Did Fay recognize herself in the photos? Probably not. I don't think it registered. Like Man Ray, Fay showed no interest in the actual physical photograph, nor in the moving video image beyond a momentary glance. Like face-to-face encounters with mirrors, a dog quickly learns to shrug it off. In video recordings that used my voice there was an initial reaction – ears up, head cocked inquisitively, but attention faded abruptly when the truth set in. It's not Bill. It doesn't smell right. TV sets and Polaroid

photographs offer nothing to a dog. Fay kept to her own realm, leaving me to my complicated agenda while tantalizing my imagination with moments of intersection. I became curious about her. What was she really thinking about? Sometimes it was clear. Other times not. To a dog a ride in a car might be magical. As a front seat passenger Man Ray used to stare at me in awe as I steered – at my face and then down to my feet then back to my face then to my hands and back around again. What did he think I was doing? Fay loved the car but had no such curiosity. Once in she crouched low on the floor in the back. Just drive.

Fay was mesmerized by twins. A visitor and his twin brother came by Sixth Street one day. I thought she would never stop staring at them – first one then the other and back. She didn't stop, back and forth the entire visit. You should have seen her.

65

Ring (four variations), 1992

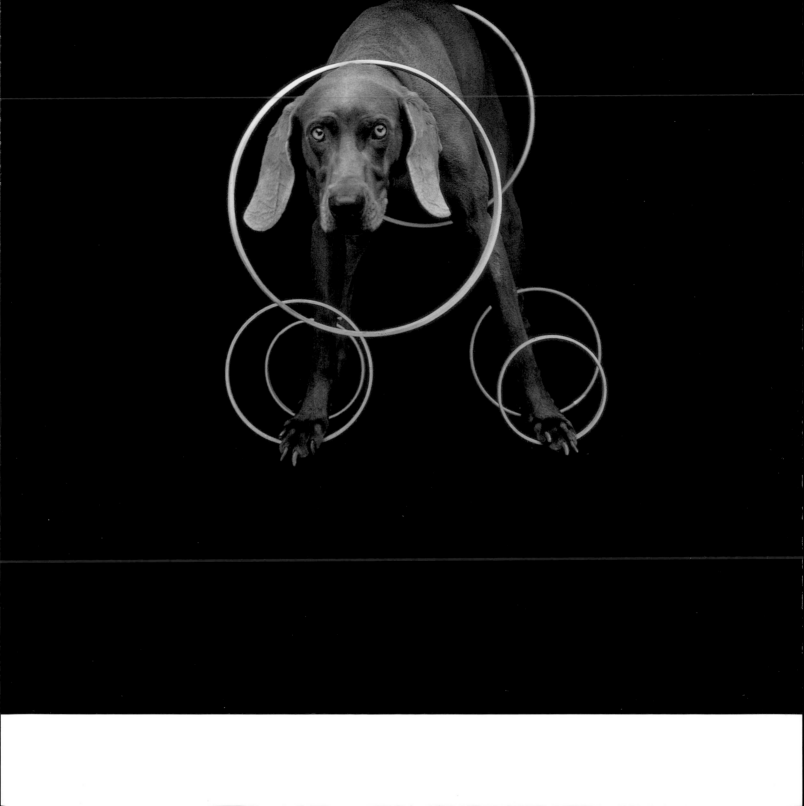

Untitled, 1994

Untitled, 1994

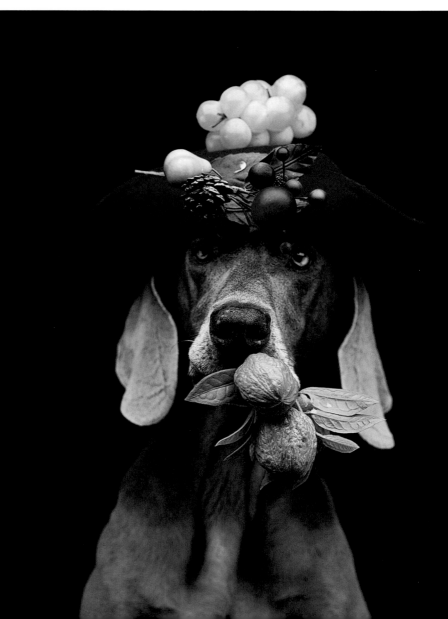

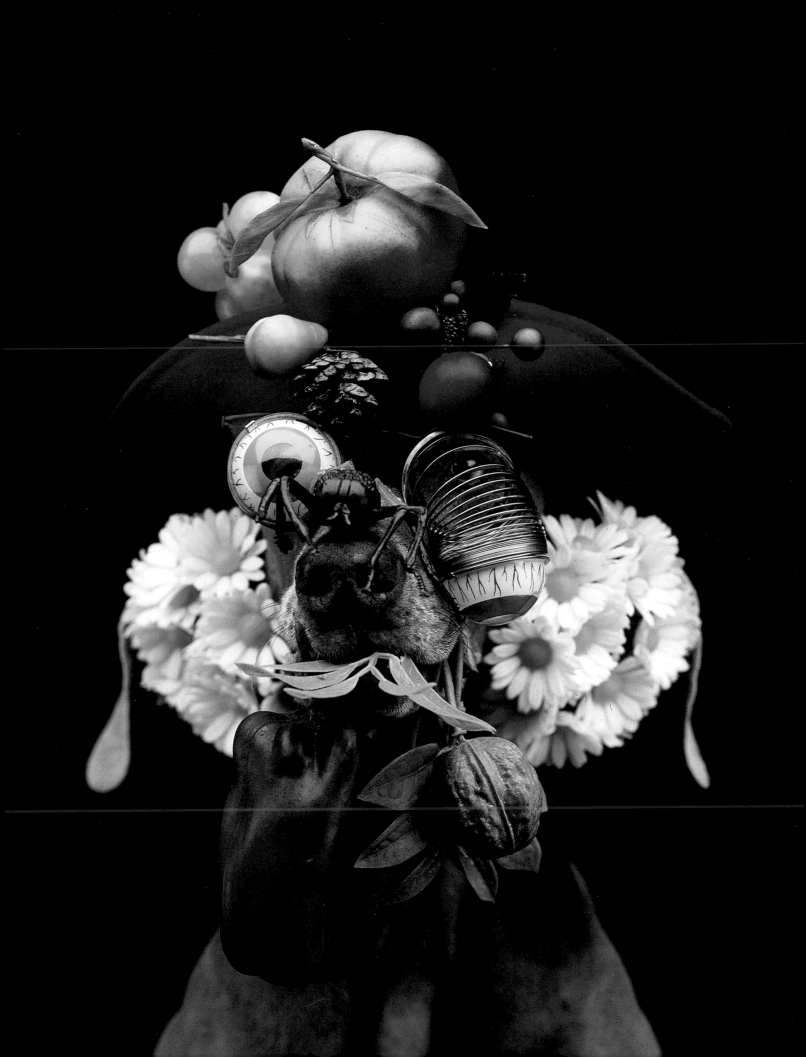

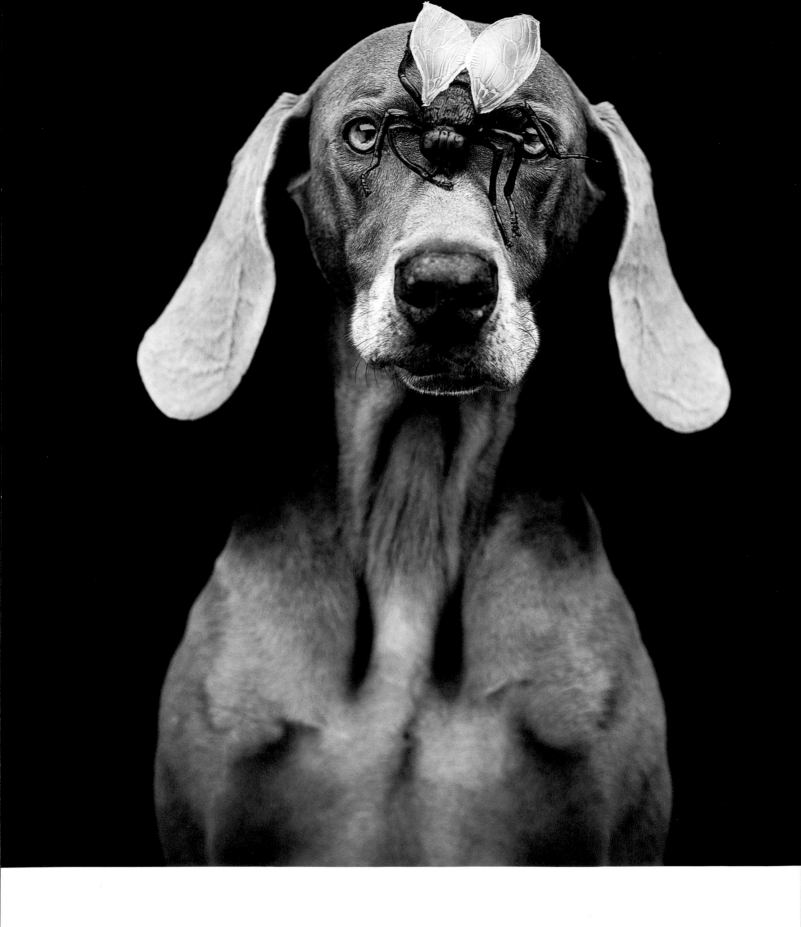

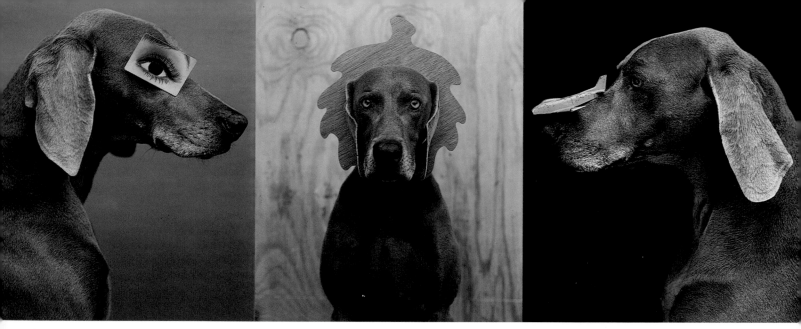

Eye, Eye, Eye, 1994 Acorning, 1992 Jet Plane, 1994

Flywear, 1994

Celestial, 1995

Bog, 1992

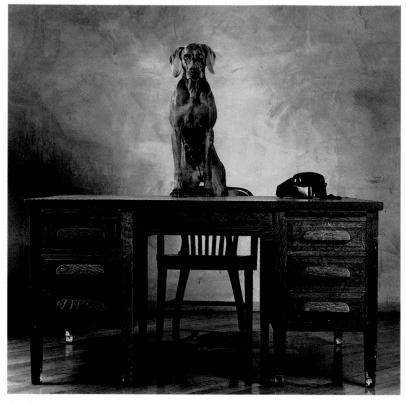

Right and following pages:
120 mm contact sheets,
1988

Receptionist,
1988

I didn't use the Polaroid 20 x 24 exclusively.

In the beginning I shot black and white with a twin lens Mamiya C330, then in 1975 I bought a Hasselblad – both cameras used 2 1/4-inch-square formats (120mm). Until 1979 when I began to use the Polaroid, all my work was shot in this format and printed on 11 x 14-inch Agfa Brovira photographic paper. A painter by nature and schooling, I am a resident alien in the world of photography. Somehow I managed to bumble along, seeking help when confronted by an obstacle. Color for instance. I wanted to work in color in my studio. But I didn't know how. Help came in the form of an extremely quiet, well-educated photographer I first met in Brussels in 1986, a young woman named Katleen Sterck. I bought an inexpenseive introductory set of strobe lights and some basic grip equipment that Katleen recom-

mended and we turned my home into a photo studio. In the year ahead with Katleen's help I made many photographs, both color and in black and white with Fay in relation to furniture.

Among my favorites are those with the curvy fringed easy chair left over from a *Vanity Fair* shoot. And a partner's desk I had found in a Goodwill in Springfield, Massachusetts, on which I ran my office, and under which Fay camped and tended goal whenever she could lure us into a game. I always had a soft spot for stepped bedside tables and so soon there Fay was up on one. Katleen developed the negatives and printed them. In the process of working, Fay and Katleen quietly connected. In 1988 master printer Eric Jeffreys began printing my black-and-white negatives. He also became Fay's good friend.

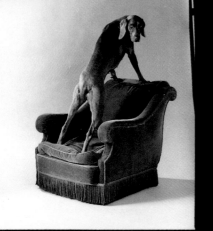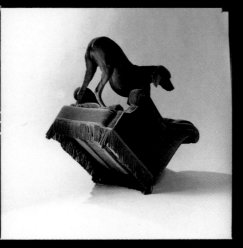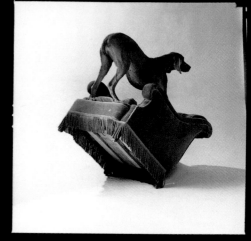
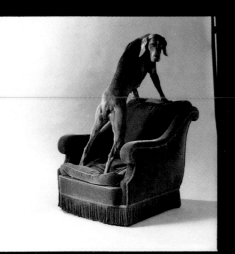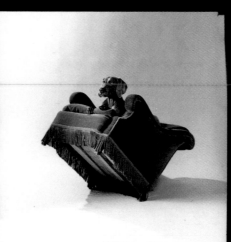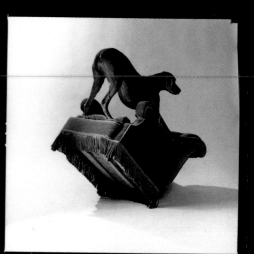
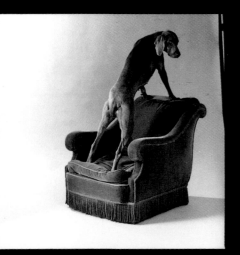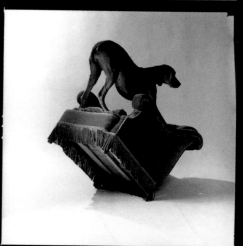
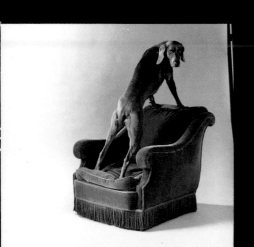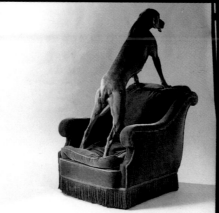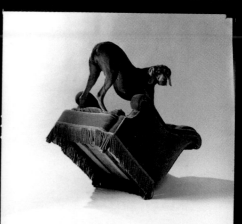

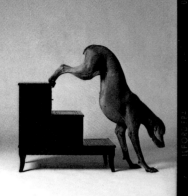
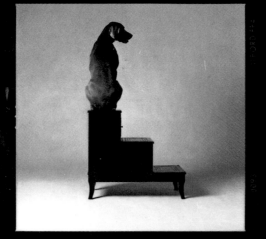
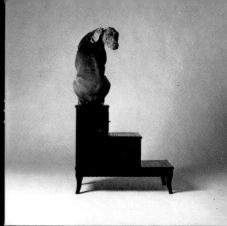
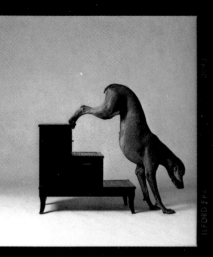
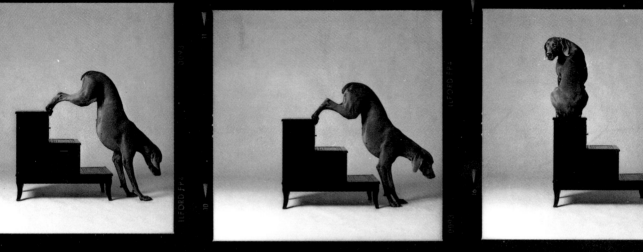
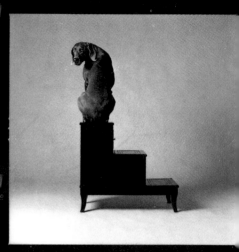
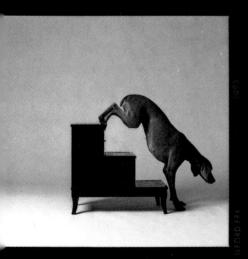
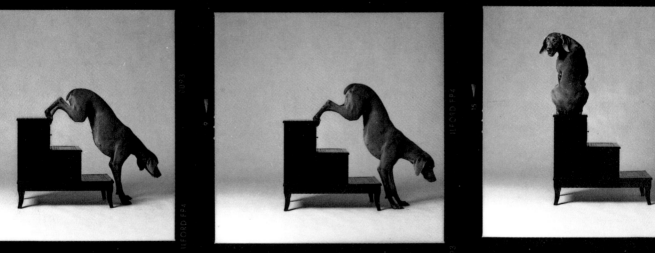
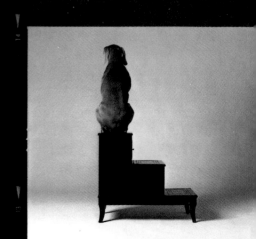
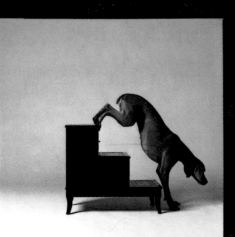
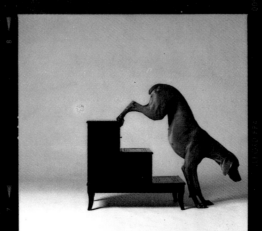
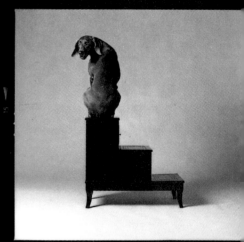

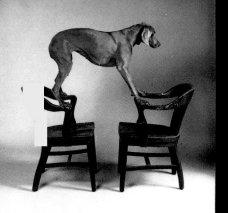
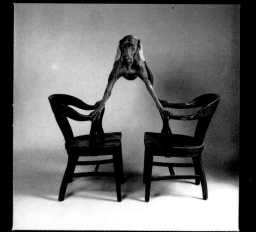
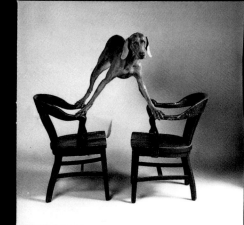
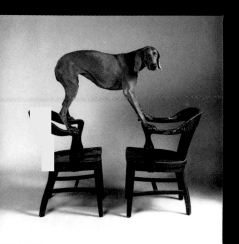
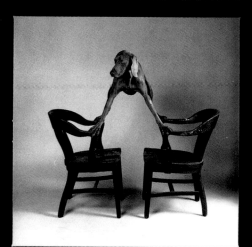
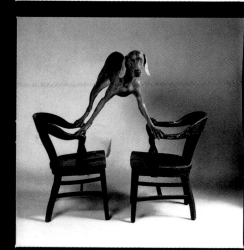
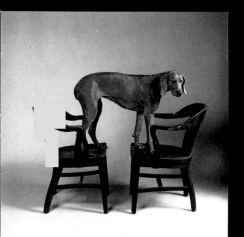
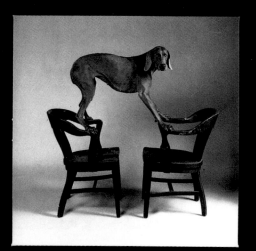
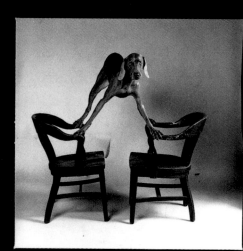
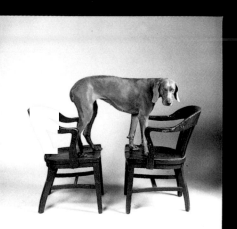
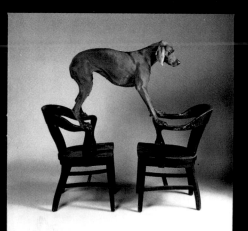
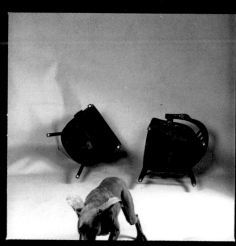

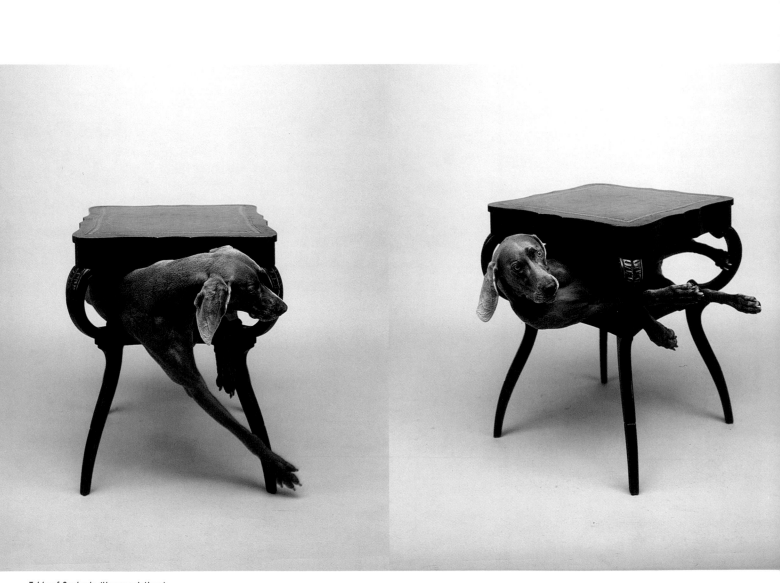

Table of Contents (three variations),
1988

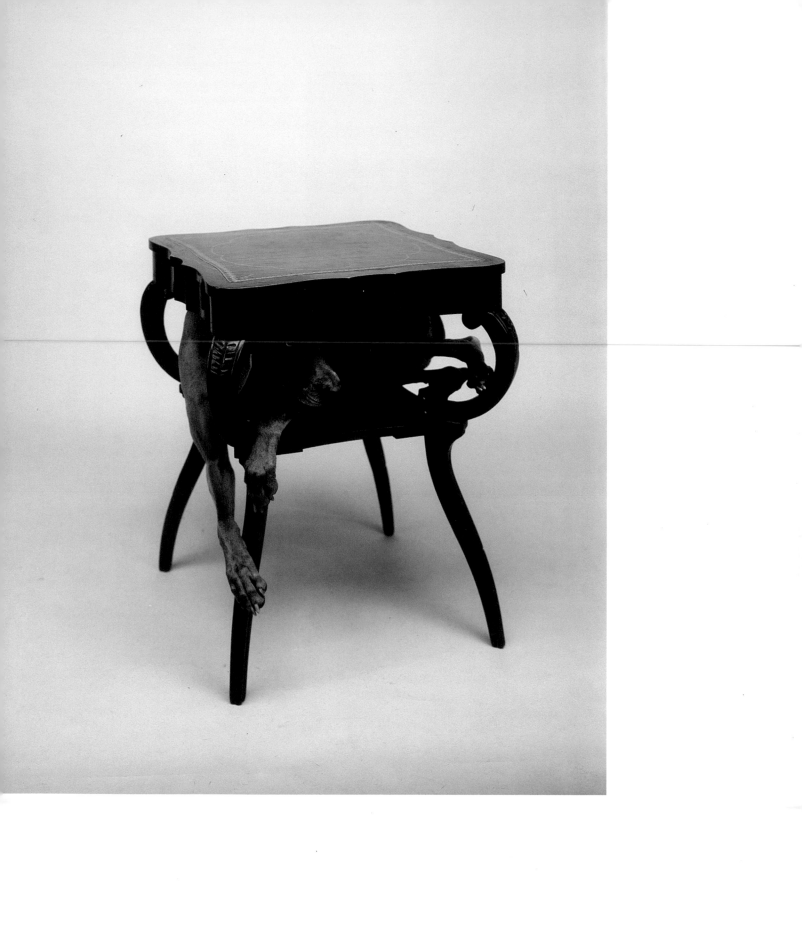

Katleen's skill as a color printer encouraged
a new aspect in my photographs. For the
first time I started taking pictures on location
in Maine and upstate New York using color
negative film with my own camera, the
Hasselblad, trusting that the results would
come to a productive end. Fay loved working
in the fields and woods upstate. She reveled
in her own nature to track and scent wildife.
A simple command, "Wait!" caused her to
freeze her position, allowing me to consider
and compose a shot. Then, with the audible
click of the camera shutter she released her
pause and burst into fast forward, tail up,
head down to continue tracking deer, scenting
pheasant, geese, and wild turkey. The glow-
ing light from the Hudson valley softened
and tinted Fay's velvety coat.

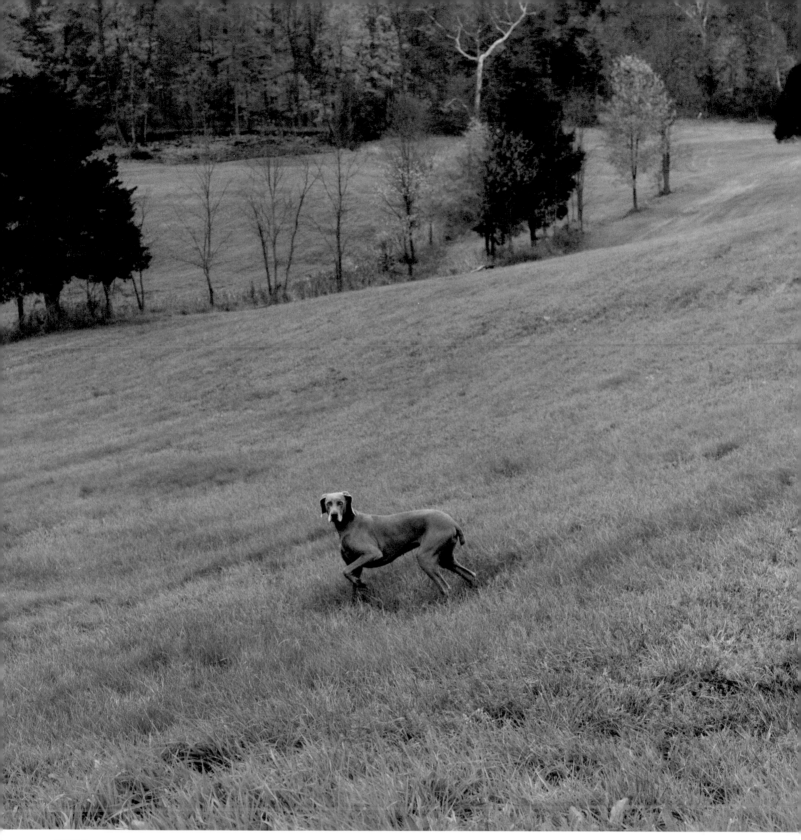

Pastoral,
1991

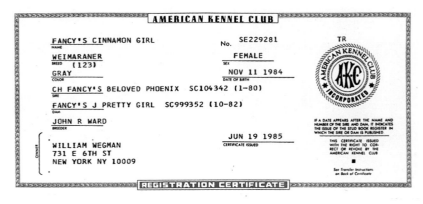

Fay's AKC registration

Fay was four and it was time to find a mate for her. Hanging around city dog runs wasn't practical and the whole singles scene was a turnoff. Word got out and I was deluged with offers on Fay's behalf. Rather than jump into a hasty liaison I called an expert: Virginia Alexander in Germantown, Maryland, founder of Reiteralm kennel, long-time officer in the American Weimaraner Club. Jeannette Ward said Virginia Alexander was the queen godmother of weimaraners in America. Talking to Virginia and Jeannette I was immediately thrown into a different world. A world of three-, four-, and five-word names like Shadowmar Barthaus Dorilio, Bings Konsul Von Krisdaunt, Ronamax Rajah v.d. Reiteralm. "Here Ronamax Rajah v.d. Reiteralm, come boy." A construction site of sires and dams and double grand dams, with Ch., CD, NRD, NSD, SDX, BROM stacked, lodged, benched, and tagged. What is angulation anyway? Virginia's knowledge of the breed is truly remarkable. I completely relied on her for direction in choosing a mate for Fay. Virginia had never met Fay but most of Fay's ancestors were of Virginia's breeding and she knew a lot about her, more than me in many

Ch. Ladenburg's Arco V Reiteralm (Germany)

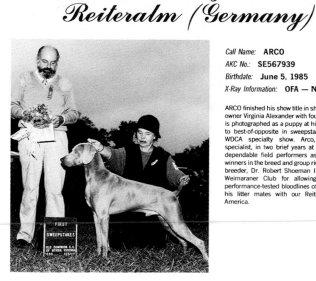

Call Name: ARCO
AKC No.: SE567939
Birthdate: June 5, 1985
X-Ray Information: OFA — Normal

ARCO finished his show title in short order handled by owner Virginia Alexander with four 4-point majors. He is photographed as a puppy at his ring debut enroute to best-of-opposite in sweepstakes at a supported WDCA specialty show. Arco, the high octane specialist, in two brief years at stud, has produced dependable field performers as well as consistent winners in the breed and group rings. We thank Arco's breeder, Dr. Robert Shoeman III, and the German Weimaraner Club for allowing us to blend the performance-tested bloodlines of this young dog and his litter mates with our Reiteralm line here in America.

```
                    ┌── Blucher V Annenhof "V", RGR, J1, H3, RS, MS, VBR, BTR, SPURL
        ┌── Mark V Einkorn "SG/SG", RGR, CACIB, CAC, EUROPA SIEGER,
        │   1987 Intern Schonh Ch., J55H J61, H166, RS3, MS2, SIL
        │           └── Bianka V Einkorn "G", RGR, J2, H1, VSWPL
FURST VOM SELZTAL "SG/SG", RGR, J55, H164, SIL
        │           ┌── Ingo V. Zehnthof "V/SG", SRG, CACIB, J1, H2, MS
        └── Anka V Selztal "SG/SG", SGR, AZP, 181, G2, MS4
                    └── Gundel V Wasserschloss "SG", J1, H1, SCH.H. PRL+2+3, MS4, W
                    ┌── Dirk VD Rauhen ALB "SG/SG", RGR, J3, H1, G1, RS4, MS4, VSWP2, SchHP1, W, HD-FREI
        ┌── Nobel V. Wasserschloss "SG/SG", RGR, J53, H181, MS3
        │           └── Jessie V Wasserschloss "SG/SG", RGR, J1, H1, G3, VSwPL, W, MS4, SIL, HD-FREI
FANNI VON DER LUSSHARDT-HD-FREI
        │           ┌── Arco V Selztal "V/SG", RGR, J2, H1, MS4, RS4
        └── Anka VD Lusshardt "SG/G", RGR, J62, H165, SCHFPL, MS4
                    └── Dixie V Tannenhof "SG", SGR, J3, J1, H3
```

Breeder: Dr. Robert L. Shoeman III **Owner:** Virginia Alexander
Address: 17301 Germantown Rd., Germantown, MD 20874 **Phone:** (301) 428-0841

95

Reiteralm

ways. Fay, after all, was a Reiteralm girl whose lines went back six times to Virginia's own Ch. Maximilian v.d. Reiteralm, whose noble exploits were detailed like Arthurian legend. Virginia had just the right guy in mind for Fay. Arco Laudenburg von Reiteralm, a total outcross, she explained, a completely unrelated gentleman dog from Germany. He now resided with Virginia in Germantown, and was the ideal mate for Fay. Arco, so named for his high octane personality, had energy, the look, and the bloodlines going back to some of Germany's finest weimaraners. The question: Would the German Weimaraner Club sanction the union? They needed to know Fay's pedigree, her hip X-ray data, her training, and performance scores with birds on land, ducks in water, and proof of her courage to protect her owner. When Virginia called Arco's breeder in Germany to ask permission for the marriage she was asked, "How high did Fay score in the field?" Virginia's explanation that Fay neither hunted nor competed in the ring, that she was an artist's model, was met with the chortling response: "What is she? A prostitute?" After much ado Virginia finally convinced the German Breed Warden that Fay was worthy, and the marriage plans began.

Courting Disaster. I drove with Fay down to Germantown in the spring of 1988 to intro-duce her to Arco and to meet Virginia for the first time. Katleen, Andrea, and Alexandra came along for the ride. In a car full of pretty girls Fay was in her element. She loved women and looked after them, sharing emotions both gleeful and grave. Virginia was more animated than I had imagined. In a swirl of gestures she showed us around. There were many horses and dogs, woods and fields, a barn or more, a white colonial house, a husband, and Arco. Arco seemed slight compared to Fay. Virginia recited a litany of his virtues and why he was genetically correct for Fay. His delicate flews, exquisite topline, perfect pasterns, moderate stop, deep brisket, high tail set, and on and on. My eye was on Fay who was exploring the perimeter of the farm. I showed Virginia how to play with Fay. "Throw something over her head. After she brings it to you tell her to drop it. You will have to say it twice." Arco may very well have been a perfect specimen but Fay was too busy retrieving sticks to notice him. Arco had to wait. The plan was, the next time Fay came into heat she and Arco would spend a week together. In October Fay began the telltale signs and I had to get her to Arco before the tenth day, the beginning of the fertile period. Unfortunately I had to be away at the time. My assistant Katleen drove down with her and dropped her off. Fay wouldn't let Arco near her. Virginia says she went crazy without me.

The next time arrived at the end of March 1989, and another conflict arose. I was scheduled to photograph First Lady Barbara Bush at the White House with her dog Millie and Millie's two-week-old puppies for the cover of *Life* magazine. Bad timing, but the good news was Washington, D.C., was quite near Germantown. We loaded up a rental truck with Polaroid photo equipment, racks, strobes, film pods, all the stuff you need to run the big 20 x 24 camera. I followed in my own car with Fay, taking a slight detour to Germantown to personally reintroduce her to Arco.

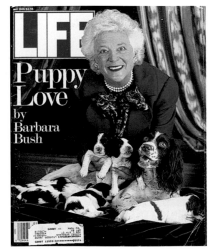

Life Magazine,
May 1989

84

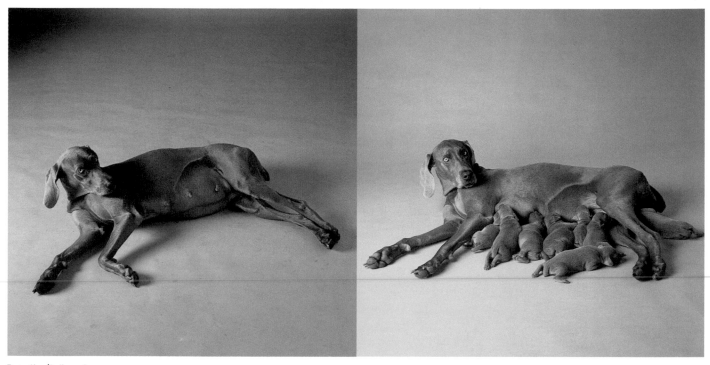

Expecting/Delivered,
1989

Fay seemed happy about Arco this time and appeared ready. I told her I'd be back in a couple of days, then moved on to Washington where I met up with the crew in the rental truck. I transferred the bags from my car to the truck before entering White House security. At the gate a K-9 guard with a German shepherd boarded our truck as we stood by. The dog began to methodically sniff his way through our gear. Suddenly stopping dead in his tracks, he began to sniff frantically. "Do you have a sandwich in here?" asked the guard, pointing to my camera bag. A what? "A sandwich. Food." You can't imagine how my mind raced. Had someone planted something in my bag? Then it dawned on me. Fay had been lying on the bag in the back of the car. The scent of her heat was all over it. That was a good sign. Fay got pregnant.

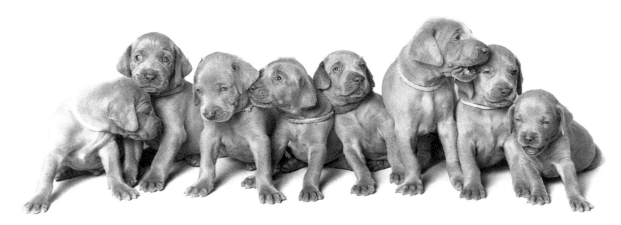

Fay's Litter,
1989, from left to right:
Blaise, Art, Speedy,
Glenn, Ken, Chundo,
Crooky, Battina

Fay was a spectacularly attentive mother,

which kind of surprised me. I didn't think she was the motherly type. But she couldn't stand being apart from the puppies even for a moment. When I handled them, Fay watched me like a hawk, counting every single one. The firstborn, Chundo, proved to be the lion of the litter. Battina, the little bat, was the runt. So small and weak was she I had to support her while she nursed. Except for one of the males, by the second day all the puppies thrived. At two weeks their eyes began to open, revealing a brilliant luminescent blue. I photographed them with abandon and I cannot recall a more spirited and euphoric time. At four weeks I started Fay on the weaning process which involved cutting her food back severely over a four-day period. On the fourth day, which called for no food and two cups of water, Fay dug in the couch and defiantly produced a large milkbone.

Once weaned, Fay avoided all but the briefest contact with the puppies. Sharp teeth! At this time I started to notice their unique personalities. I could not take my eyes off petite charming Battina. Her comic antics, more kitten than canine, separated her from the pack. However when I reached into the pile at random it was almost always big Chundo that I picked. His big head and almost Chow-like features and camel-like walk easily distinguished him from the others. He was by far the calmest and easiest to work with. The others grew rambunctious as the days progressed. The bigger of the two females, Crooky, named for the white marking on her chest and her crooked tail (which got shortened on day three), was awarded most hyper, Glenn and Speedy a close second and third. Blaise, named for the considerable white spot on his chest, grew fast, becoming almost as large as Chundo. Ken with his well-formed head and perfectly proportioned body was the handsomest as well as the most needy. His laser blue eyes seemed to always be on me. Art was a smaller version of Chundo with his pleasant disposition and dromedary manner.

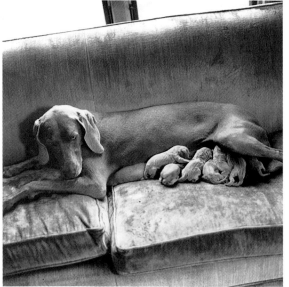

The first day, 1989

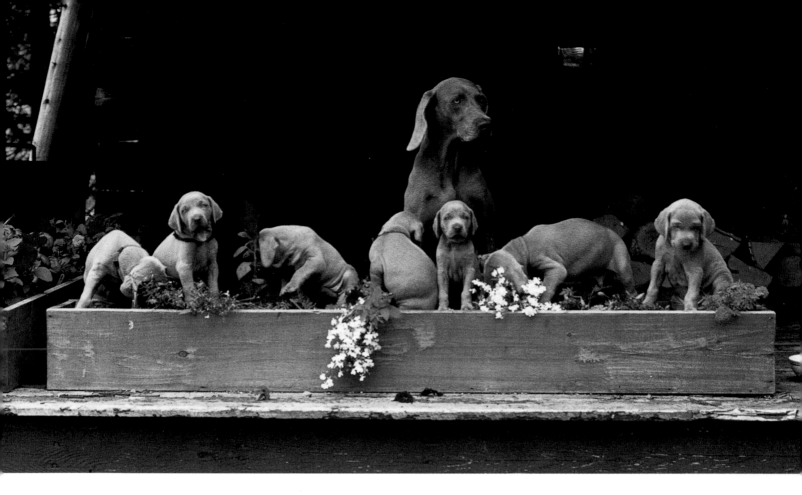

When they were five weeks old I loaded them in my jeep and headed for my cabin in Maine. I kept them there for the next two months, sharing the fun with everyone on the lake. The summer of puppies. In early October 1989 the puppies were twelve weeks old and it was time to choose and separate the litter. Relief mixed with sadness. Virginia drove up from Maryland and took three males, Speedy, Art and Blaise. Fay hardly noticed their absence. She seemed immune to them. Chundo stayed in Maine with my sister Pam. Pam had her eye on Ken but took Chundo on my insistent urging. Chundo was the perfect dog for her, protective yet mild-mannered and very good looking. Enthusiastic, hyper-athletic Dave McMillan, marathon runner, wind surfer, pilot, dentist, took Crooky. Good thing. He was the only person I knew who could keep up with her. Ken found the perfect home in Middletown, Connecticut, with my Aunt Lois, where he is

much loved. He now goes by the name of Hogarth but to me he is still Ken, handsome and sweet. The spunky Glenn went to the home of my friends Jan Hashey and Yasuo Minagawa in New York where he lives like a lord. They renamed him Laredo. Get it? quizzed Jan. La-RAY-do.

I kept Battina. There was never any doubt.

On the lake in Maine, 1989

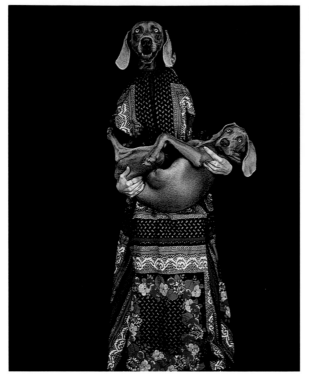

Mother and Child,
1989

Fay and Batty's relationship was full of theater. Fay accepted Batty, as she did Chundo and Crooky, as part of the troupe, but she made sure they knew their place. Always cool, now she added stern to her portfolio of manners. Greta Garbo cross-fading with Joan Crawford. When Batty was two months old she entertained herself with a kittenesque pinball-like game which involved her chucking a tennis ball against the rungs of a chair. "Complicated ball," I called it. The game amused both Batty and me to no end. Fay watched for a while then launched a tumultuous assault. After that Batty would not even look at the ball. I was very upset with Fay, who was not in the least apologetic. I decided rather than interfere I'd let them work it out. Once we were back in New York at Sixth Street, Fay established her territory around which Batty fit neatly. Going in/going out: first Fay, then Batty. Eating dinner: first Fay, then Batty. Batty wouldn't even look at a milkbone before Fay had hers. There were no squabbles. Fay's bullying was never outrageous and at times it was perceived as charming. Batty always looked to Fay for cues. When called, she first turned to Fay for the Okay. Only then did she proceed.

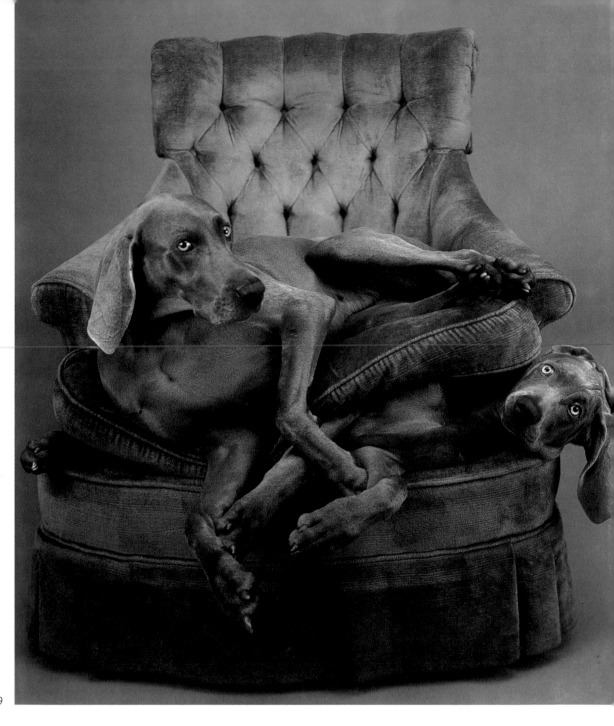

Underdog, 1989

In our frequent games of ball in the field upstate, I tried to give Batty a little head start by grabbing on to Fay's collar to hold her back for a moment. Fay got wise to my scheme and developed the strategy of creeping away toward the direction I was supposed to hit the ball. It didn't occur to her that all I needed to do was hit the ball in the opposite direction. That would be breaking the rules. And that was my choice. I quickly resolved this dilemma by putting two balls into play, one for Fay, another for Batty. Since they both liked those dense rubber dog balls, I got two identical yellow ones. Incredibly Fay knew which one was hers even as it sailed over her head. If it was Batty's she would not even offer it a blink. Batty's ball was whichever ball Fay didn't want.

I soon developed a huge affection for Batty, the sweet darling underdog.

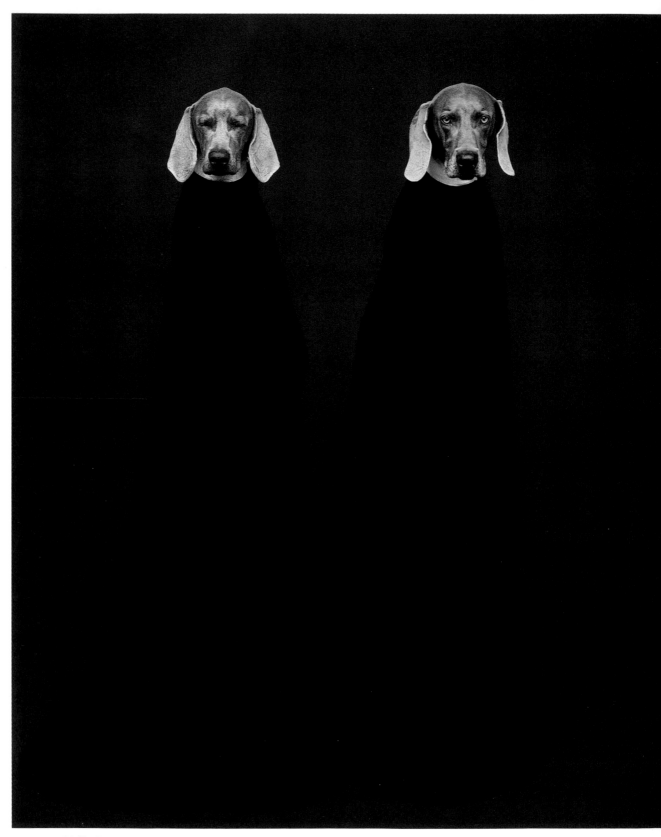

Innocence and Guilt, 1990

Working with Batty was a dream. Her body and mind were in many ways the opposite of Fay's. Batty was limber, flexible to the extreme. Her poses were effortless, natural. She just was. Fay tried very hard and it showed in the photographs. She was more self-aware. Performing similar poses on the same set, Fay sometimes came across in photographs as scheming, malevolent, whereas the lithe Batty appeared comic, a saintly innocent. There definitely was something interesting going on between them. I became sharply aware of their individuality and began to explore it further in the pictures that followed.

Speaking of affection, in 1991 I met and fell in love with Christine Burgin. When Christine met Fay something dear and magical happened between the two beauties. I do believe Fay put a spell on her. Christine fell for me and we soon became a couple. Fay showed no jealousy whatsoever towards Christine. Christine, not a dog person, became one toward Fay. Batty did as Fay told her and our house was a harmonious one.

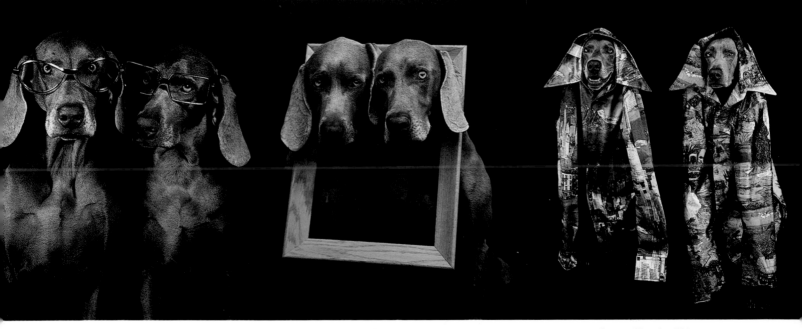

Eyewear, 1994 Framed, 1992 Town and Country, 1994

Long Ride Home,
1990

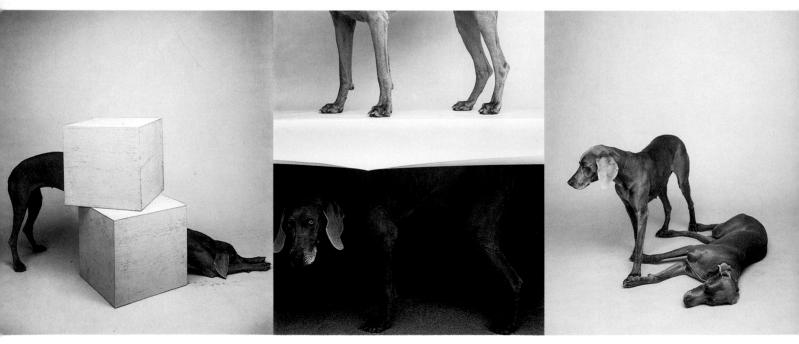

Transmission, 1992 Underworld, 1994 Shadow, 1993

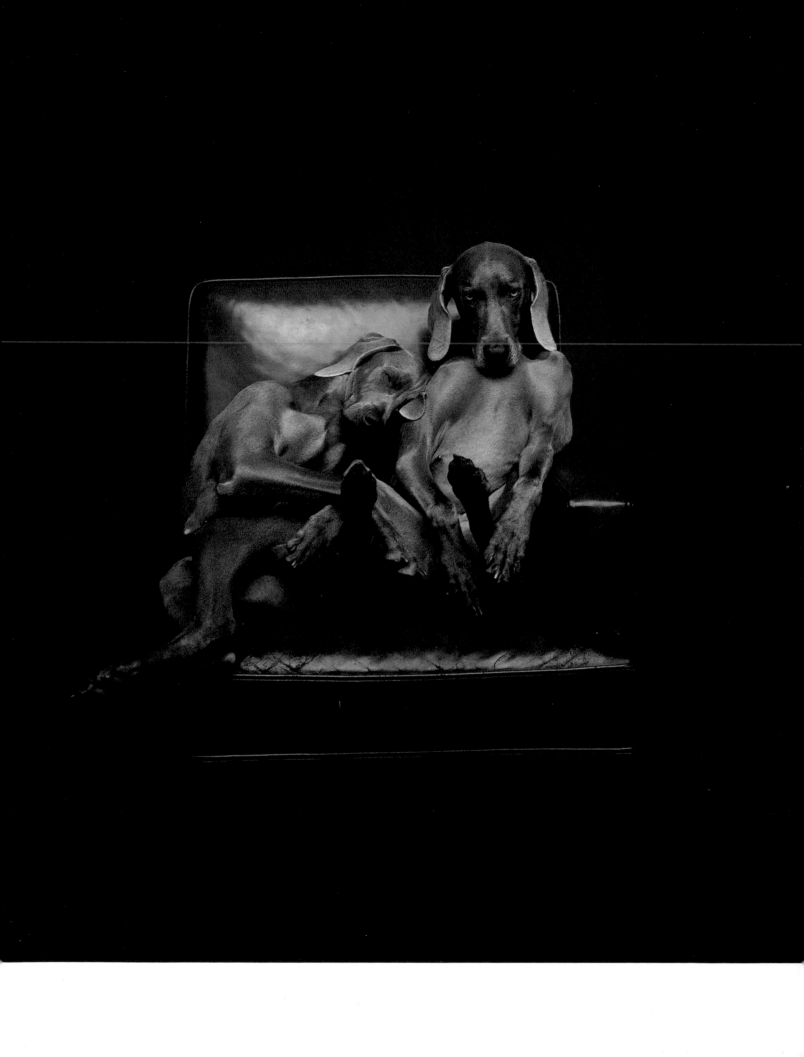

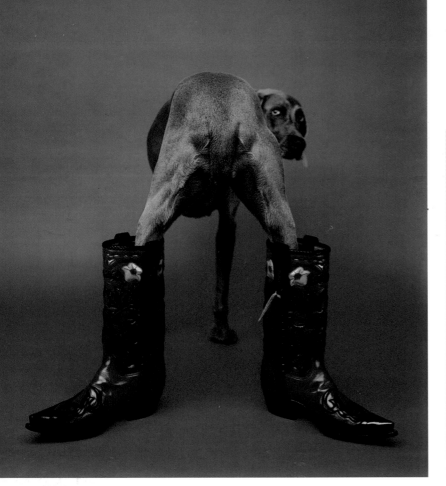

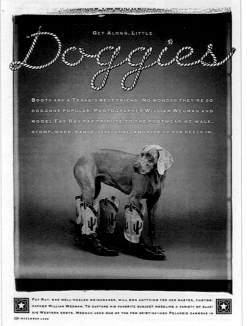

Tripod, 1989

Texas Monthly, December, 1989

Cowboy boots and diamonds.

Batty and Fay demonstrated their remarkable ability to interact photographically with the most disparate of props in two unique series of photos, one commissioned by the magazine *Texas Monthly*, the other by a British newspaper, the *London Sunday Times*. My favorite shot for *Texas Monthly* is of Fay backending into a pair of really spectacular polychrome leather boots. In the *Times* shoot we worked with millions of dollars' worth of diamond and emerald jewelry, an interesting change from my usual yard sale, flea market fare. Batty looked sidereal in diamonds. Her petite form and dreamy demeanor emphasized the sharp brightness of her glittering, opulent accessories. Fay's extraordinary ears provided a more than elegant armature for her diamond-studded earrings. One work from the diamond shoot – *Becoming* – stands out, a triptych with Fay and Andrea having nothing to do with carats and everything to do with elegance and transformation. In the left panel Fay's head is cradled by Andrea standing alongside her, adorned in a glamorous gown, long satin gloves, and a stunning diamond necklace. In the center panel Andrea appears to be *wearing* Fay. The necklace is now on Fay who appears to have grown eyelashes. The right panel completes the sequence. Fay has become Andrea. For me this work sums up all that I had been thinking about in the realm of the anthropomorphic. Other than that, it was fun tossing priceless stones around the Polaroid studio, balancing them on dog's noses like old hats from the Salvation Army as hefty armed guards from Bulgari, Cartier, Tiffany and Harry Winston nonchalantly looked on.

94

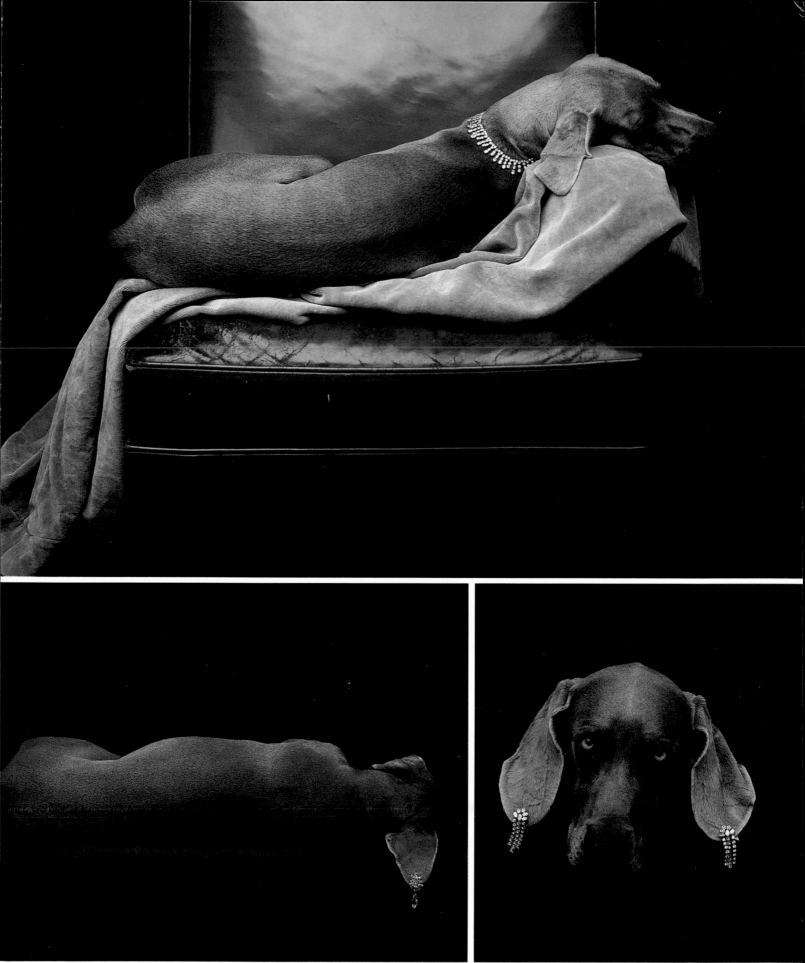

From the *London Sunday Times*,
November 18, 1990

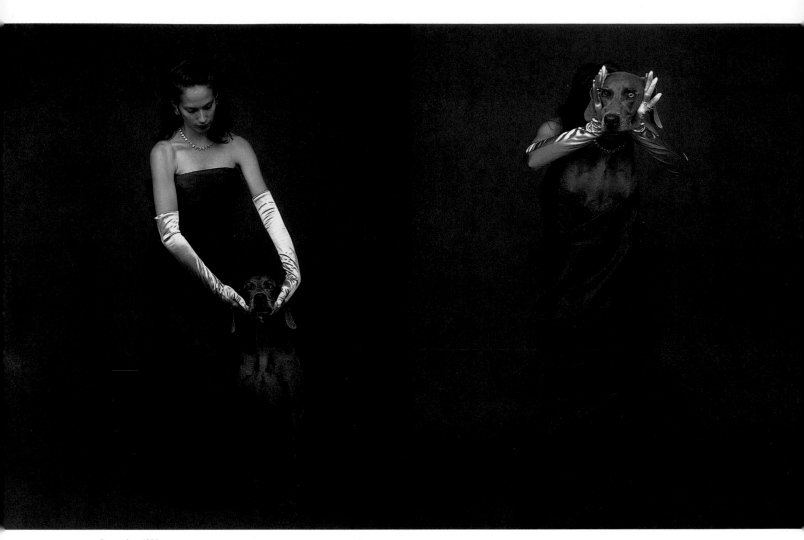

Becoming, 1990

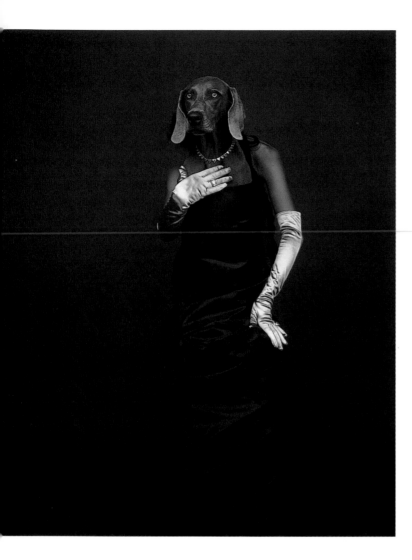

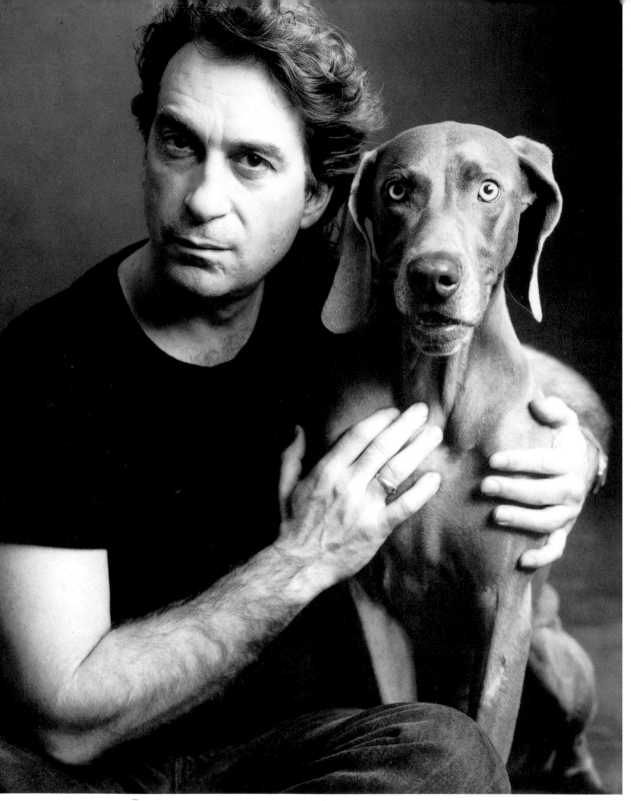

William Wegman and Fay Ray, 1988
Photographed for The Gap ad campaign
© Annie Leibovitz

As a famous artist with a dog (or as an artist with a famous dog) I got to go on talk shows now and then. In 1992 I took Batty and Fay on *Late Night with David Letterman* when his show was still with NBC. It was my fourth appearance on the show, but my first with a dog since Man Ray in 1982. I was almost a regular. I felt Letterman respected and understood my work. Late in the afternoon the day of the show I was very relaxed and feeling groovy hanging out with celebs in the green room. The dogs were getting a lot of attention and cheese danish and they were lapping it up. The time: 5:30. Time to stand by at the curtain just offstage and await my cue. "Please welcome artist William Wegman and his dogs Fay Ray and Battina." I sauntered onstage. Suddenly things went terribly wrong. Terrified by the extremely loud Paul Schaffer band, Fay made a crouching beeline for Dave's desk where she was buffeted by his welcoming outstretched arms. She tried to hide, diving under my "guest" chair, but it was too small. Batty looked confused. I was paralyzed. Dave wanted to get right to the story about Man Ray's encounter in the NBC halls with Kate Jackson of *Charlie's Angels* back in 1982 on the day of my first appearance, but I failed to respond to the prompt. Instead I watched as Fay spun out of hiding and hunkered off the set. Batty followed her. Afraid the dogs were going to get on the lobby elevator and get out onto Sixth Avenue I got up and walked after them. We weren't invited back.

With Fay, television was risky. We stuck to photography for a while.

The Letterman Show, 1992

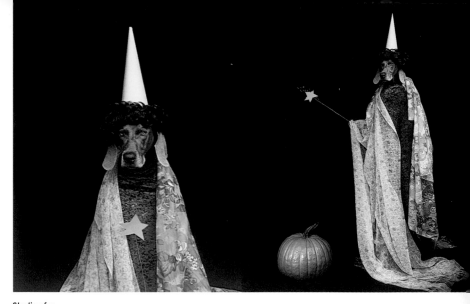

Studies for
Fairy Godmother, 1991

In the fall of 1991 I met with Marvin Heiferman and Carole Kismaric. They had a book idea for me. Fairy tales. The meeting took place around a big glass table in the loft dining room at Sixth Street upon which they plopped down a heavy folder, containing photocopy images of every known fairy tale, rhyme, and legend. As Carole and Marvin pitched their ideas about montage, concept, and layout, I slipped into a daydream. Like my dogs, fairy tale characters were the subjects of transfiguration. I awoke convinced that "Cinderella" and "Little Red Riding Hood" were stories about my dogs. I accepted the challenge.

Casting "Cinderella" was easy. Sad dreamy Batty who was already the color of cinder: Cinderella. Powerful celestial Fay: Fairy Godmother. Domineering venial Fay, the Evil Stepmother. Handsome noble Chundo:

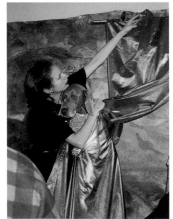

Andrea Beeman helps
to transform Fay into
the Fairy Godmother.

the Prince, but of course. The only casting problem were those horrid stepsisters. Enter weimaraner godmother Virginia Alexander, who arranged for the arrival of two adult females from Maryland and a bonus, a splendid litter of ten young weimaraner puppies belonging to Sharon Hartmann of West Virginia to transport the royal coach and Cinderella to the palace.

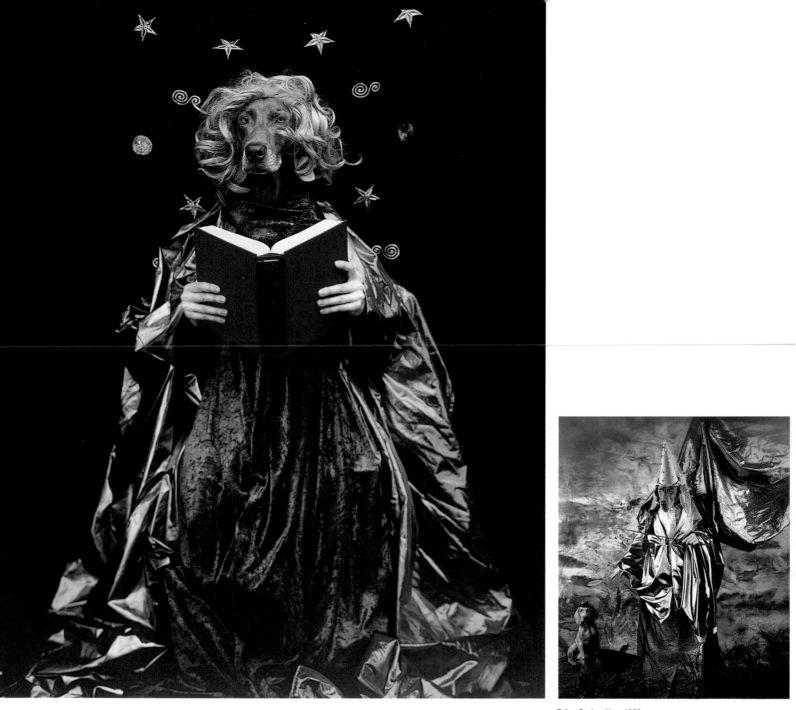

Fairy Godmother, 1992
from *Cinderella*

I made test shots, auditioning costumes, props, and wigs. Having roughly sketched out the story I leaped into production. The Polaroid 20 x 24 was set up in my painting studio on Bond Street. Some of my paintings became background sets, other scenes we constructed on the spot using found and borrowed props and lots of antique wallpaper. I had a big crew of assistants, especially on the day the ten puppies arrived.

Everyone's hands were full of them. The first shot involved the two adult dogs from Maryland. There were anxious moments as the two were being dressed as the stepsisters and positioned on the set. For the two dogs it was their stage debut although their owners assured me "it was a piece of cake." They had been practicing at home. At the first bright flash and pop of the strobe, one of the "stepsisters" freaked out, launching

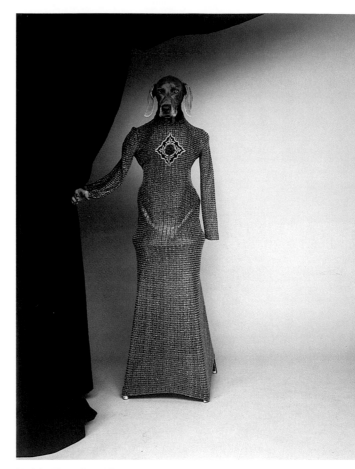

Study for Stepmother, 1992

off the stage in a panic and carrying the set with her. A second attempt proved fruitless. After a third, she fled and I had to give up on her. The other stepsister, Pewter, performed her role flawlessly through the inventive use of a flashlight brought along by her owners. Wherever the light was pointed the dog looked. All well and good but the story clearly called for *two* stepsisters. Fay to the rescue. I dressed her in the polka-dotted gown of

the first stepsister and positioned her at the makeup table before a boudoir mirror. In the mirror Fay's eyes beamed back at me standing by the camera. She had saved the day. If Batty was the star, Fay the consummate professional carried the story. Working in front of Andrea's expressive arm and hand gestures and with quick costume and set changes Fay transformed her countenance from haughty arrogance to godly benevolence.

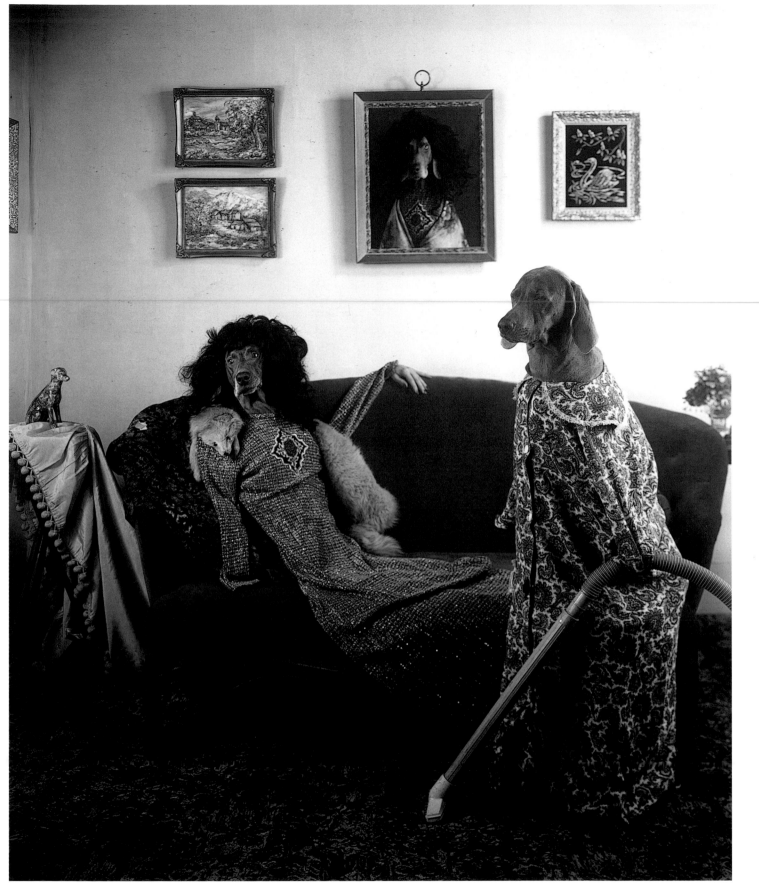

Cinderella and her Stepmother, 1992, from *Cinderella*

Study for Stepsisters, 1991

Stepsisters prepare for the ball,
1992, from *Cinderella*

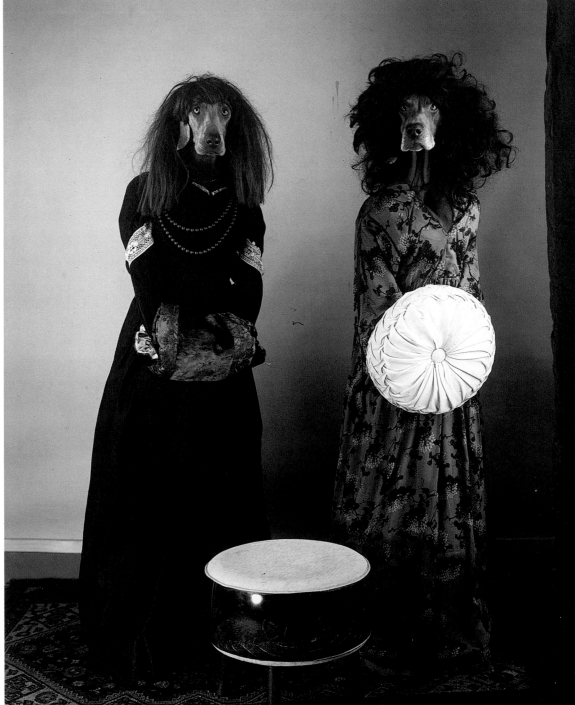

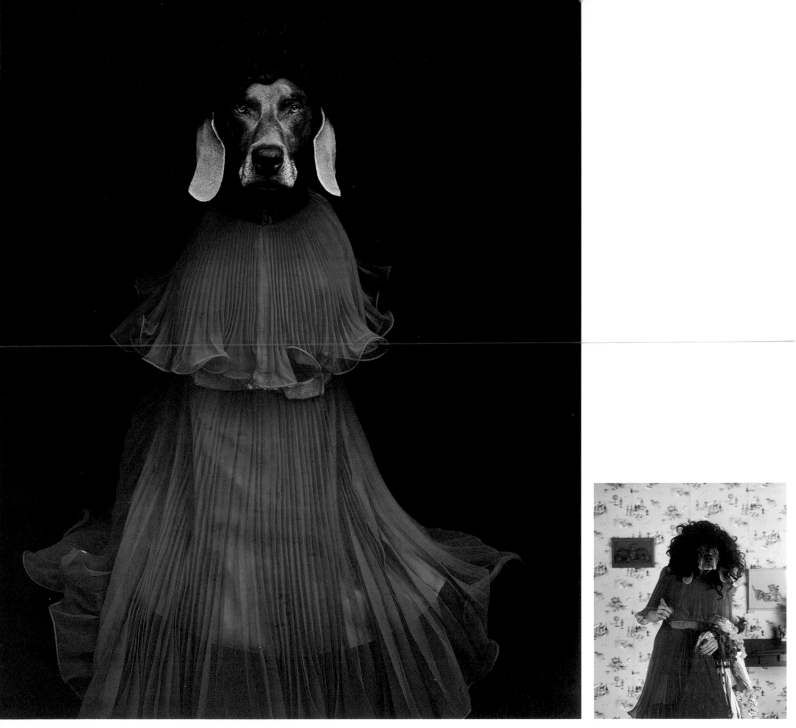

Study for Stepmother,
1991

Stepmother,
1992, from *Cinderella*

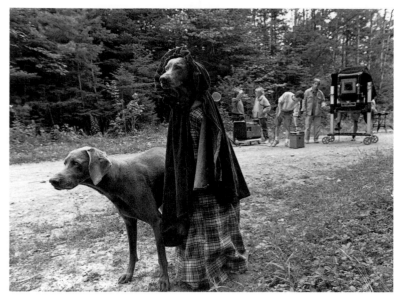

Little Red Riding Hood and the wolf on location;
camera and crew in the background, Maine, 1992
Photo: Madeleine de Sinety

From the royal to the rustic. My attention turned to the woods of Maine and the story of Little Red Riding Hood. As a child growing up in rural western Massachusetts, I reached my grandmother's house by crossing a great field of blackberries, briars, and assorted wildlife, no wolves but plenty of tempting distractions. Today as then I seldom attend balls, but walks in the forest are common. I felt more at home in this story. I had just acquired York's Lodge across from my cabin in Maine, an old rustic inn complete with grand stone fireplace and haunting native taxidermy: deer, moose, caribou, and a particularly lifelike owl. Many of the rooms in the lodge provided me with elements of the set for *"Little Red Riding Hood"* except for "mother's kitchen" where the important opening scene takes place. A perfect one was scouted in the camp of friends on neighboring Lake Mooselookmeguntic. Stan Bartash, friend and Maine forester, provided directions to perfect deep woods locations. Dentist Dave McMillan fashioned extraordinary demonic wolf fang dentures for Chundo's wolf character, which he played with sinister effectiveness. My sister Pam sewed a hooded cape for Batty out of red velvet. Wearing it, Batty *was* Little Red Riding Hood. But Batty never stopped being Batty.

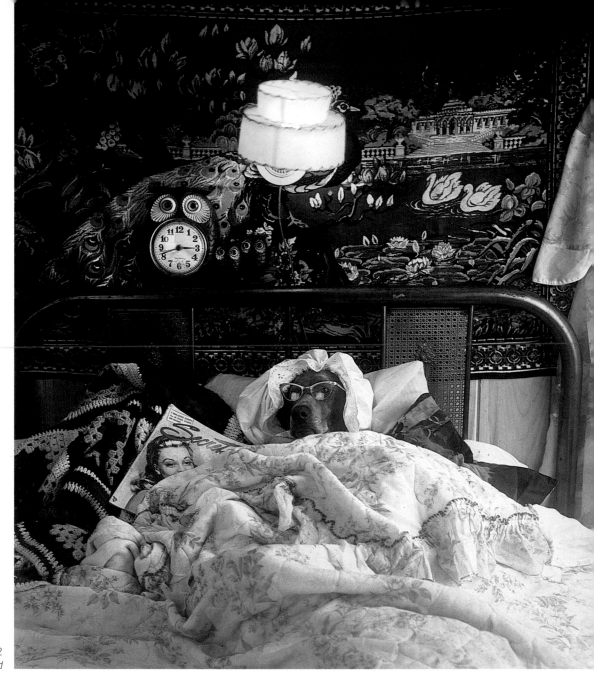

Secrets, 1992
from *Little Red Riding Hood*

Her mind wandered as she posed and she was perfect for the part. Fay, cast as both mother and grandmother, had no trouble playing both parts. She especially relished the role of sick grandmother lying in bed all day as we dressed the set around her for the shot. Fay was in fact developing a reputation for feigning illness. Curiously, she loved going to the hospital and being doctored. I remember one very late night, on Sixth Street, Fay was panting heavily, licking her mouth and acting strange. I was worried and Christine was frantic. I tried to settle Fay down but she paced and shivered relentlessly. I was afraid to wait it out and in a panic I telephoned our vet and good friend, Dr. Dale Rubin, waking her up. "You must come over at once! Fay is dying." She looked like she was. In less than fifteen minutes Dale arrived with a bleary yet concerned look in her eye. Fay arose from her deathbed to greet her: Dale! She wagged her short tail so hard her butt was a blur. All grave symptoms vanished. Fay was born to the role of sick grandmother.

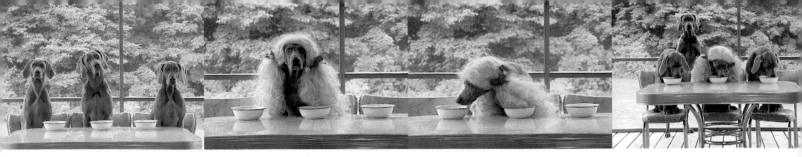

Stills from **Goldilocks,**
Sesame Street, 1993

Spurred on by the growing canine cast,

I became more ambitious in my video work. In spring 1993 I arranged for a small video crew to come to my house upstate to work on short pieces for *Sesame Street*. Alan Cohen on camera, Edgar Gil on lights and Andrea as assistant director. Fay, Batty, Chundo and for the first time in video Crooky. We began work on *Goldilocks and the Three Bears*. You know the story: Girl steals bear's porridge; sleeps in bear's bed. In a big blond wig with red bows on either pigtail Crooky was the perfect Goldilocks. She was sensational. The perky upstart managed to steal not only the three bowls of porridge from the three weimar-bears but every scene. Enthusiastic to say the least, she had to be held back by one person from the crew designated just for this job

alone. Fay put up with Crooky's ways on set but off was another matter. On a break, in a game of dog baseball Fay knocked her silly. Unlike Batty, Crooky wasn't suppressed in the least by the attack. She took the hit in stride – nothing personal – and pounded after the next ball as aggressively as ever. It wasn't as though she challenged Fay's dominance, she just paid it no heed. Of all Fay's puppies Crooky looks the most like Fay. She is smaller and there is less brown in her pale silver coat but her round bright eyes and broad cabbage leaf ears and powerfully muscled body with its graceful arching curves are Fay's mirror image. Not so her irrepressible high octane personality. That must have come from her father, Arco. For Fay it must have seemed like looking in the mirror, except Fay never looked in the mirror unless it was to look at me.

The next series of videos were shot on the neighboring farm, the same farm where *Dog Baseball* had been played six years earlier. Along with Farmer McFay and her son Chundo, the sisters Batty and Crooky appeared in their debut as the McDoubles. Joined at the hip in oversized denim overalls and posed in front of my assistant Jason Burch's two long arms, the duo demonstrated rather emphatically the number two. In another piece Fay in plaid shirt and denim overalls appeared in a small barn window to teach numbers with the fruits and vegetables of her crop. "Lemons were big on the Fay Farm this year."

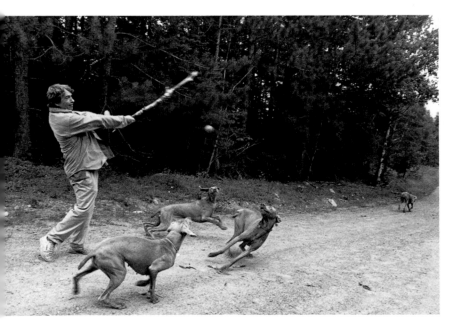

Fay gets a head start. Photo: Madeleine de Sinety

108

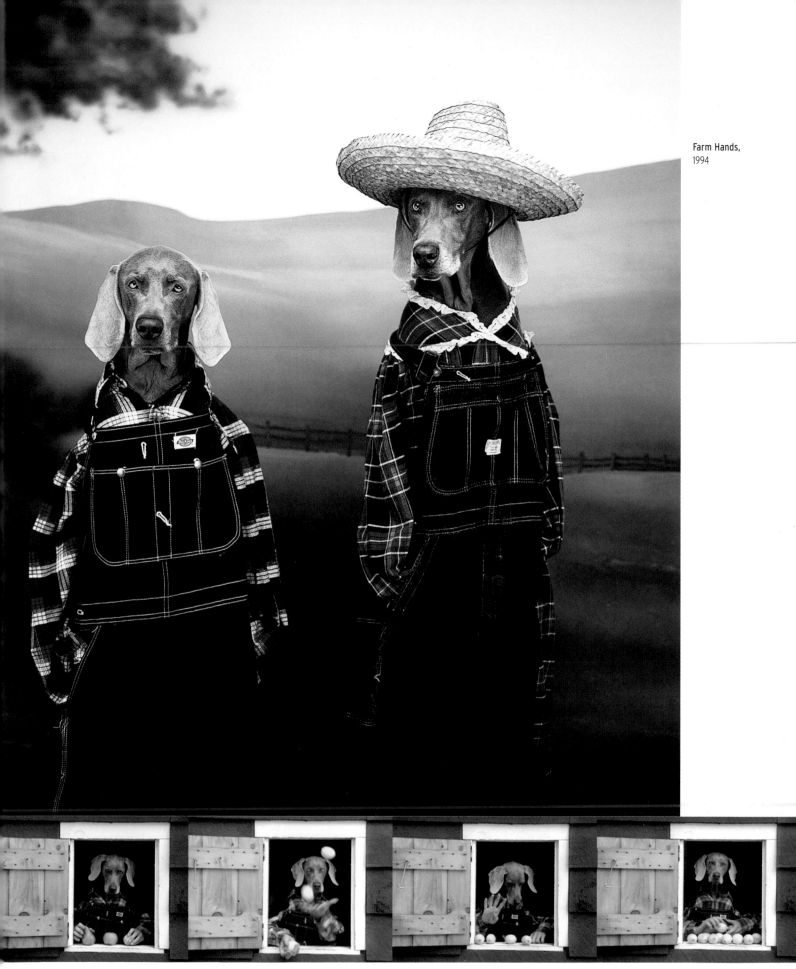

Farm Hands,
1994

Stills from **Farmer McFay**, *Sesame Street*, 1993

Dog Alphabet,
1993

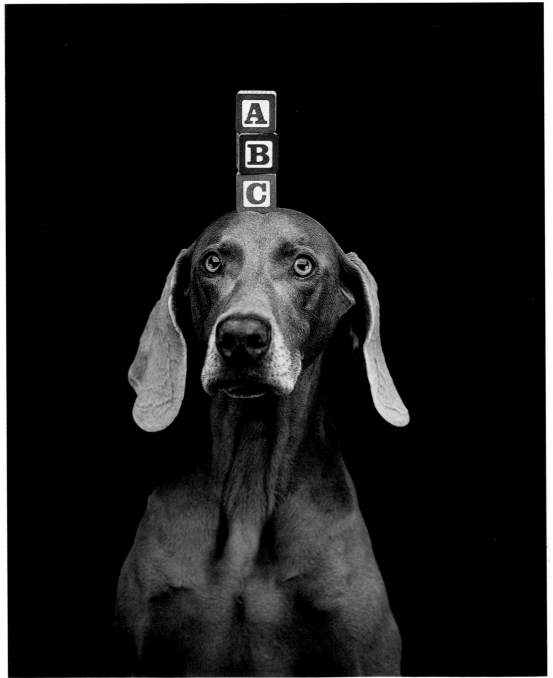

ABC, 1994

110

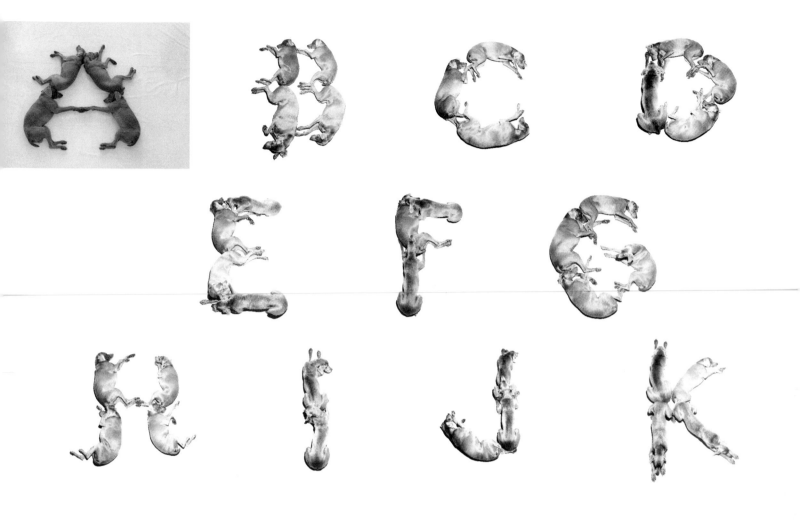

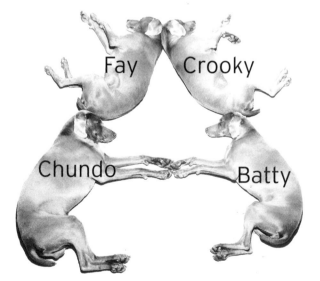

Fay Crooky

Chundo Batty

After the farm production we moved the dogs and equipment a short distance down the road to David Deutsch's studio and filmed the dog alphabet. In two days we completed all the letters from A through Z as well as the numbers 1 through 9. With the footage run backwards the dogs appear to back up and roll over into letter-perfect positions with spring-loaded Crooky leading the way.

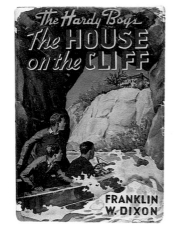

The House on the Cliff, 1927.

As a boy growing up in America in the '40s and '50s my favorite books were the popular mystery series *The Hardy Boys.* I read each one and eagerly awaited the next as my heroes Frank and Joe Hardy, sons of the celebrated detective Fenton Hardy and amateur sleuths themselves, pursued the trail of clues and criminals they encountered after school or while on vacation. As I prepared for my own afterschool projects my thoughts turned to the summer and the question of how to keep those busy hunting dogs of mine busy. Perhaps another book. What better than a detective story, I thought. I had the location and the cast. To get the lingo and lilt of the characters I read and reread every *Hardy Boy* story from *The Missing Chums* to *The Sinister Sign Post*. The tone was perfect and the plotlines just right for my dogs. Beyond mild jeopardy, nothing really bad ever actually happens. No sex or violence. You don't want that with dogs. Hunting dogs are like detectives, always sniffing for clues and tracking down suspects. With their incredible noses, amazing endurance, and awesome speed they truly have super powers.

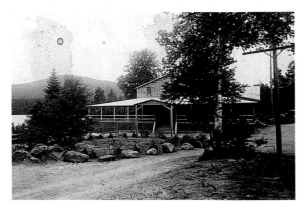

York's Lodge circa 1930

112

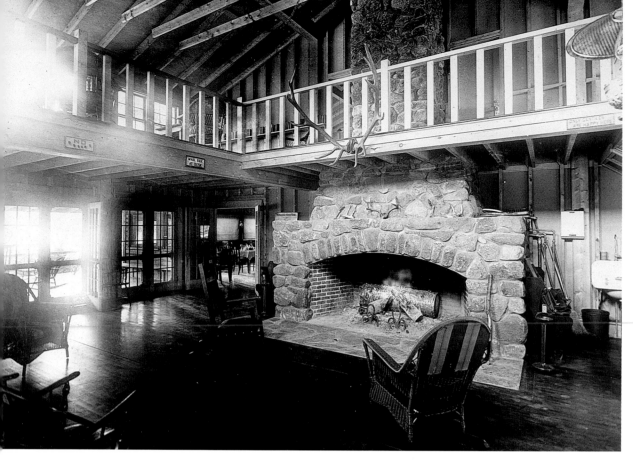

For my dynamic duo I cast Batty and Crooky as the *Hardly Boys*. "Hardly boys, they were girls and dogs." Their complementary personalities opened up many story possibilities. Crooky always looked as if she was in the presence of a bomb ten seconds before detonation. Batty's inherent narcolepsy suggested its own storyline. Brother Chundo looked mature enough to play the dad, Fenwick Hardly, as well as any other character I could imagine from chum to rogue. Fay of course would play the mom, Laurel Hardly, and the granddam in distress, (Gladiola Mason), a variation of the sick grandmother role she so relished. Fay would also play the villain, the psychotic nurse.

That summer I shot with the Polaroid 20 x 24 for two weeks, making up the Hardly Boys story along the way. As the session progressed one possible story emerged around Chundo outfitted in a trench coat and bad guy hat and Fay dressed as a nurse, his scheming accomplice. Fay looked strangely sinister in her spiky punk wig and drab green uniform. It was not so much what she wore but how she wore it. The wig caused her eyes to slant malevolently. The circumstance reminded me of Cinderella. I've often noticed how differently Fay reacted to wigs and headwear from the other dogs. Batty didn't care whereas Fay...

We got access to an abandoned military training site complete with cruise missile guidance systems and dilapidated cabins equipped with radar antennae and other mysterious elements. Pictorial fodder for *Hardly Boy*-like simulations with the dogs crouching behind buildings and tree camouflage.

When I got back to New York in the fall I had a lot of pictures and two fragmented stories. Then the movie offer came in.

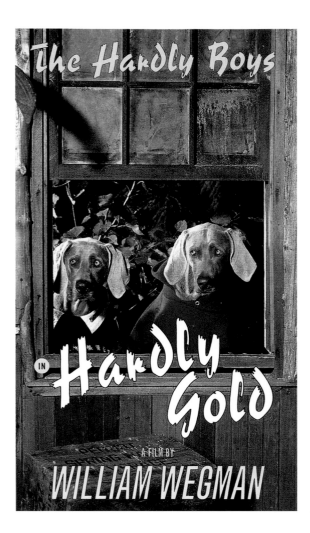

Next summer, August 1994, the *Hardly Boys* film was in production. It didn't matter that the movie offer never materialized. I decided to go ahead with the project anyway. I couldn't wait another year. The "boys" Batty and Crooky were five, approaching middle age. Fay was nine and turning white around the muzzle. Now was the time. The Polaroid crew came to Maine and we were able to work out some character and story ideas. Producer Claire Best and director of photography Phillip Hollahan arrived from Los Angeles to go over the nonscript. I had some ideas. Sculptor and set designer Jeff Smith arrived from Boston with a truckload of electronic parts salvaged from an MIT dumpster which he would use to create the boys' secret clubhouse/laboratory. The York

Lodge, our home, became the Hardlys' summer residence, the *Hardly Inn*. A lodge, a lake, a golf course, an old garnet mine, and the town's sewage treatment

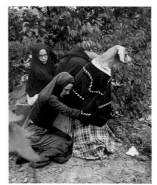

Behind the scenes

114

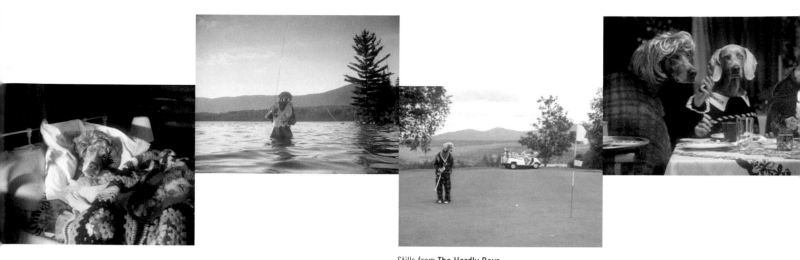

Stills from **The Hardly Boys in Hardly Gold**, 1994

plant. Certainly there would be a story there. I just had to uncover it. On August 10, the crew of twenty-two began to arrive, some from Boston, others from New York, still others from L.A.. Grips, gaffer, producer, assistant director, best boy, and DP. Christine, six months pregnant, and Steve Philbrick of Bald Mountain Camps were in charge of craft services.

We began by filming summer camp activities: Crooky—badminton, tennis, horseshoes; Batty—croquet and butterfly catching. This was good for the dogs as it gave them something to focus on—the bird, the ball, the horseshoe. For the people behind the dogs, their arms and hands, it was not so simple. In the tennis scene Crooky was costumed and positioned on the tennis court at the net. Skye Peebles, Crooky's racketeer, was called upon to hit forehand volleys. From Skye's position behind Crooky she was in effect blind. Over and over she tried but she could not hit the ball and I was afraid we were going to use up all of our footage. Lisa Martin, a more experienced tennis player, took over Crooky's tennis scenes. Skye was sent off to play croquet with Batty.

Back to tennis. From off camera I tossed the ball over the net toward Crooky's racket and shouted, "Swing." Crooky kept her eye on the ball and Lisa fairly regularly to form the

Preparing for a dolly shot

illusion of a half decent net game (for a dog). The other activities, croquet, badminton, horseshoes, and butterfly catching were thankfully less challenging. Batty was always either daydreaming or about to fall asleep as the mood hit her. Not having a script was useful at times like this. Amidst the tall fields with her butterfly net she simply looked wistful. Jason Burch, positioned in a wet suit behind Chundo, had sufficient fly casting technique and ability that he could practice Mr. Hardly's art quite convincingly. One of Fay's characters, Laurel Hardly was obsessed with golf. Fay looked stunning on the links in her plaid slacks and ruffled argyle sweater which made up for Andrea's meager golf strokes. Mrs. Hardly's motto—Competition/Concentration/Crystallization—

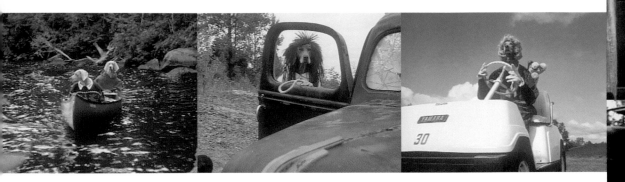

Stills from **The Hardly Boys**
in Hardly Gold, 1994

kept the ball rolling. In her dual roles of
Aunt Gladiola Mason (Fay in a gray wig and
pink satin bathrobe) purportedly under the
spell of a powerful sedative administered by
the Psychotic Nurse (Fay in spiky punk wig
and nurse's uniform), Fay's performance
raised itself to a virtuosic level not captured
on film since the days of Lon Chaney.

In unleashing Fay, Batty, Crooky, and
Chundo from the constraints of still photog-
raphy certain problems arose. In still
photography you need only a fraction of
a second. How do you create movement
when the dogs are dressed? How do you
get them to look at something other than
me for a period of time? When I call one dog
how do I keep all the others from looking?
And a bigger question, how do you sustain
a narrative with the dogs' limited movements
and minimal expressions? That question
remains unanswered. I refused to resort to
the kind of special effects that make the
dog's mouth appear to move or any other
anatomical manipulations that destroy
their inherent beauty and integrity.

To suggest movement we placed the
costumed dogs on a rolling platform dolly
and pulled them through the set. Fay and
Batty didn't exactly love the dolly. Every
time it moved they lurched and hunkered.
On film they appeared to float rather than
walk. You half expected them to wave like
beauty queens in the Rose Bowl parade.
On the other hand the canoe scenes were
easier than we anticipated. Batty and Crooky
genuinely enjoyed puttering around the lake
in their magical canoe.

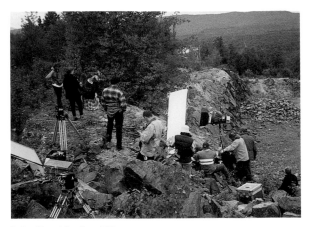

On location at the Garnet Mine

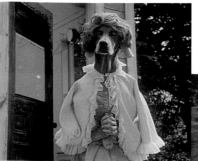

The production was our most ambitious ever. Everyone was stressed to the breaking point (except for the dogs who were having a fine time). New illusions were created on the wing.

The shooting lasted eleven days and nights. People involved in filmmaking are perhaps accustomed to this kind of urgency and administration but we were novices. Nevertheless the process became addictive. When it was over we wanted more. Some of us.

Back in New York that fall, after rough-cutting the picture, with Steve Hamilton, and Andrea. I went into the sound studio to attempt a voice-over narration. I was accustomed to the sound of my own voice with the dogs having come to the conclusion that only I could speak for them. What seemed to work best was a flow of narration and dialogue, a cross between speech and thought bubbles with narrative bridges. Only short bursts of dialogue seemed to work. Longer stretches of speech tended to detach from their subject. One character's voice I could not get right was the voice of

Fay as the Psychotic Nurse. This character required a voice from another planet or at least a voice other than mine. I dragged Andrea into the sound room and gave her some lines to recite. As Fay's arms she was after all part of the character. Andrea's gestures and voice blended perfectly and Fay's character came to life.

The finished film was shown in several film festivals that year, including the Sundance Film Festival.

Christine was due November 11. An auspicious date I thought, Fay's birthday. How would the dogs react, we wondered? We had heard horror stories. We were especially worried about Batty, who was petrified of children. Children were unpredictable and didn't respect her territory. Once she had snapped at a toddler at the Polaroid studio. On November 6, five days ahead of schedule, Atlas, named after the sonogram machine where he was first made visible, was born. Following advice gleaned from a hospital pamphlet I brought Atlas's baby blanket home so that Fay and Batty could get used to the scent. I let Batty sleep on it. When we brought Atlas home Batty was beside herself, confused and jittery. Fay was calm and collected and soon Batty quieted down. By evening she was watching over the newborn in the crib. Atlas was accepted. I never had to worry about Batty again.

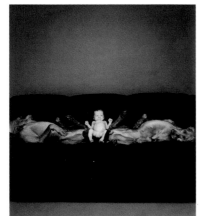

Atlas, 1994

Batty was five when I decided to breed her. Not that I was in a rush to raise another litter of puppies. With two dogs and a baby and the increasing demands upon my time, not to mention Christine's, now was not a good time. Fay was ten and I imagined she would live at least as long as my sister's dog Leibe – sixteen years. Fay was in great shape. She was made of iron.

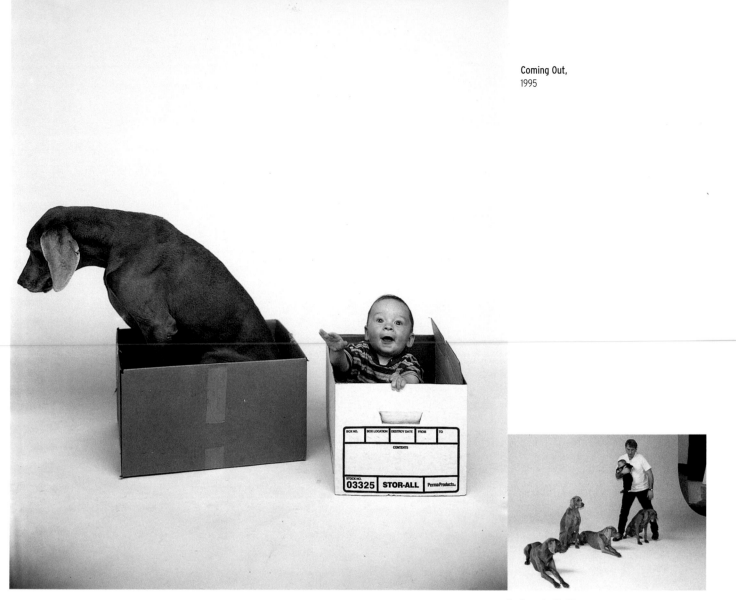

On the set with Atlas

But it would be unhealthy for Batty to wait any longer.

I asked Virginia Alexander to help me find a mate for Batty. Like Fay, Batty had no show record but she was not without resumé. Since *Cinderella* her star had risen. Although Fay was more widely known, Batty had more sex appeal. Virginia would keep an eye out as would I. I would know him when I saw him.

On the way to visit Christine's parents in Mercersburg, Pennsylvania, we stopped at a dog show where I met Virginia with the weimaraner contingent. After the show we were invited to a party at the home of Al Greenfield, long time weimaraner breeder. Mr. Greenfield was a friend of Grace Kelly, Princess Grace of Monaco. As a wedding gift he gave the prince and princess one of his weimaraners, who lived to a ripe old age in Monaco. A relative of Fay? I do not know.

All the dogs from the show would be there along with many others, giving us a wide selection from which to choose a mate for Batty. Mr. Greenfield's home and adjacent kennel were situated on a rambling property of woods, fields, and ponds. There was a big white colonial house and near it a swimming pool.

119

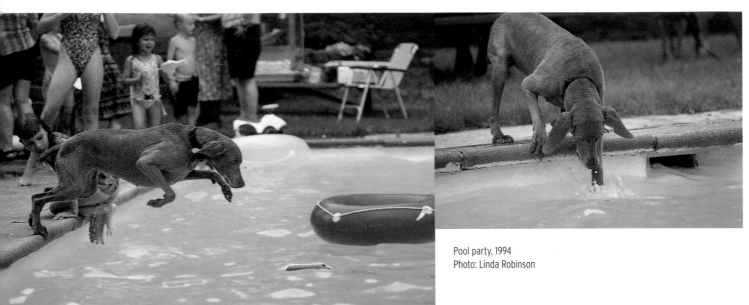

Pool party, 1994
Photo: Linda Robinson

Batty who was shy around other dogs stuck close to me while Fay immediately found action at the large swimming pool near the house. She was diving in after a plastic squeaky toy carrot that she had stolen from another dog. The children were taking turns tossing it in the pool for her. Over and over again. I left Fay with her sport and wandered down the hill with Batty to a meadow. Three weimaraners were jumping over a hurdle and retrieving something. One dog was especially good, flying over the hurdle and bringing the object back to his

trainer, a tall slim woman with an entranced proud mother's expression. Not wanting to interrupt, I watched for a while until I heard his name: Ferdinand. He was a handsome dog with a big head and a keen expression. I ran back up the hill to find Virginia. I wanted to know more about this dog. I found Virginia at the pool with the crowd that had gathered to watch Fay fetch the squeaky carrot. Virginia was keeping count. Sixty-two by the time I finally I got Virginia's attention. Ferdinand? Yes, she knew the dog. He was one of hers. Virginia was his breeder and part owner with Barbara Jacobs, the lady I had seen in the meadow. Barbara was agreeable to a match and we planned to meet when Batty next came into season.

The first week in March, Batty was ready. The calls were made and off we went. Was I ready? I had never witnessed a mating before. I wasn't sure I wanted to. After all, Batty was my little girl.

Ferdie Jumping

It was snowing. Ferdinand arrived with Barbara, and Virginia followed with a surprise guest, Arco. It was the first time Fay had seen him since their wedding night. I have no idea what they said to each other, how they felt or what they thought. Five years is a long time. A very long time to a dog. Batty eagerly approached Ferdinand who I noticed was smaller than I remembered but handsome nonetheless. Batty was more than eager, flirting outrageously with Ferdinand. They kissed. Really. It was charming. Fay too was friendly and encouraging. Virginia decided that the back porch would be the best place for the mating. We cleared the room of furniture and put a rubber mat down over the cement floor. Ferdie, overcome with excitement, was acting discombobulated. Batty had to wait for him to settle down. The dogs tramped around in the snow as Ferdie acquainted himself with his new surroundings. Then it was back to the porch.

Virginia and I coaxed them on with words of encouragement. Fay, Christine, and Barbara were banished to the kitchen by Virginia. Ferdie, an accomplished obedience performer, was conflicted by the presence of Barbara, his trainer. Christine was happy not to have to watch. The mating was achieved not without great effort. I'll spare you the details.

Sixty days later on May 12, 1995, Batty went into labor. The day was eventful but not joyful. A stillborn female did not survive and Batty had a hard time delivering all of her whelps. Batty's final pup was delivered by Dr. Greene at the animal hospital. We named him Dr. Greene. Four males survived.

121

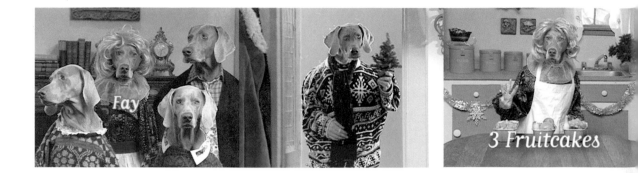

Where was Fay in all this? I'm not sure. I was busy with Batty and the new puppies, busy along with Christine as we experienced the wonder of our first child now five months old. On a more routine level I was busy editing, trying to complete two new videos shot earlier that winter and spring: *Alphabet Soup* and *Fay's Twelve Days of Christmas*.

Fay had been difficult to work with. She had panted a lot and allowed only me to carry her onto the set. She yelped if someone else tried to. Maybe it was the onset of arthritis, common in older dogs of her breed. A blood test showed a minor protein aberration. Nothing significant, the vet said. Back to work. Post-production took place at Spin Cycle Post, a mid-

town editing studio where Andrea and I worked with editor Steve Silkensen. Steve had worked wonders with the *Hardly Boys* and *Alphabet Soup*. Multitalented musician Larry Lipnik, who had worked with us on *Alphabet Soup* and other *Sesame Street* pieces, would find the right music.

Jason, Arnie, Lisa, and Andrea on the set
with Chundo, Batty, Crooky, and Fay.

Editing was slow. Reviewing the footage I
noticed Fay looked unwell. Maybe it was all
that red and green surrounding her on the
Christmas set. One evening when I returned
home from editing I noticed that Fay hadn't
touched her food. It was strange also that
she didn't follow me upstairs to the kitchen
as she normally did. In the morning I
brought her to our veterinarian Dr. Dale
Rubin. Fay perked up upon seeing her. She
was very calm while Dale drew blood and I
held her steady. Fay was not bothered by
these tests. She liked the attention. To Fay
trips to the hospital were fun outings.
Probably nothing to worry about. Maybe a
stomach virus. Fay and I left the vet's with a
few cans of prescription dog food and pills
to settle her stomach. When the blood tests
came back the next day Dale called me
at the editing studio. Not good, she said. I
heard "low proteins" along with some other
medical terms. This didn't seem right.

Fay and Atlas
Saturday, June 3, 1995

Fay wasn't that sick. Given Fay's history of feigning illness, I didn't trust Fay and I didn't trust the results of these tests. To my eyes she looked healthy. More blood samples were taken. On Dale's advice we consulted her colleagues at the Manhattan Veterinary Hospital, Dr. Greene, Dr. Gil, Dr. Haberkorn and Dr. Marter. Dr. Maleo, an oncologist from the Animal Medical Center, was also consulted. More tests confirmed every suspicion. Acute leukemia. Almost unheard of in dogs. Fay's uniqueness in this case was very unlucky. We decided to go with chemotherapy. There was only a very slight chance that it would prolong her life even a few months, less than 5 percent, but it was a chance and Fay seemed so strong.

Fay was happy at the hospital. I brought her a toy, the squeaky carrot which had replaced the tennis ball as her favorite. Her home was a cage in the basement where all overnighters stayed. The doctors, nurses, and technicians were generous and let me stay with her long after visiting hours were over. They opened the door to her cage so

that Fay could come and go. She made friends with the staff there and roamed the basement floor with their pets. After two days at the hospital Fay stopped eating and she was fed intravenously. She looked very thin. Under doctor's advice I forced nourishment, orally injecting her with turkey, chicken, and veal baby food from little jars as often as possible. I desperately wanted her to get strong. Christine and Atlas made daily visits, which I looked forward to as much as Fay. After a week of pampering, prayer, and chemotherapy Fay's condition improved a little. In spite of all odds she was going to beat this disease! If anyone could it would be Fay. On Friday we picked her up in the car and took her home to Sixth Street.

The homecoming was subdued but eventful. Batty was happy to see Fay and Fay gave Batty a cryptic sidelong glance. Fay perked up enough to play with her squeaky plastic carrot. She was happy to see Batty's puppies, now three weeks old. Atlas and Fay played with Fay's carrot on a blanket that Christine placed on the ground

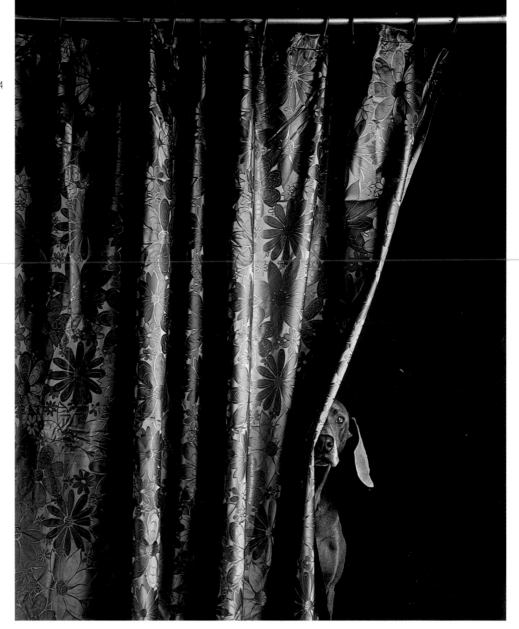

Curtain, 1994

in the backyard softened with hay from
upstate. A few friends visited. Pictures were
taken. Fay and Batty had a number of con
versations which I could almost overhear.
On Sunday Fay's condition deteriorated and
I brought her back to the hospital. This
time she stayed in her cage with her back
to me. I lay with her on the floor of the cage
but she didn't have anything more for me.
On Wednesday, June 7, 1995, Fay died.

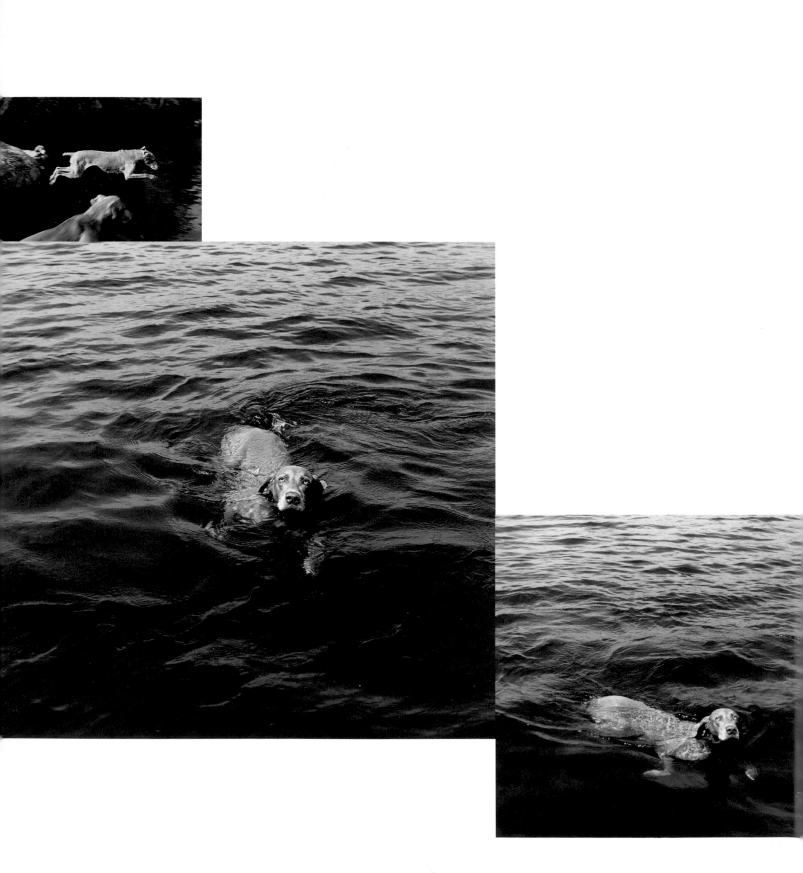

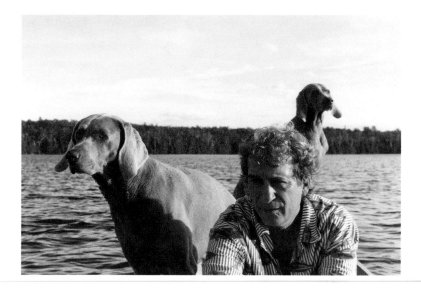

In my dreams Fay got to spend another summer at the lake where she taught Batty's boys valuable lessons like how to jump off a dock, get the ball, hold a pose. She watched over Christine and kept her side of the bed warm at night. For Batty she continued to lead the way, keeping her in bounds. That summer Chundo was so happy to see her he almost let her win at the new game: roof ball. Fay forgot about the silly carrot. She and Baby Atlas were inseparable. He could really hit a ball far and Fay never tired of retrieving it for him. Fay lived another ten years to the ripe age of twenty, remarkable for a dog of her breed.

In reality Fay was cremated, her remains placed in a white metal container a little smaller than a coffee can. In July we brought her to Maine. It was in my mind to scatter her ashes on the lake but I couldn't. Christine put her on the dresser in our bedroom. In the fall we took her back to New York and put her on the dresser by our bed. And then back to Maine in the summer. Some years have gone by and I have yet to release her. The wind is always blowing in toward me on the dock. I gave Fay's collar to Crooky who is the most Fay-like of her offspring. I see Fay in Chundo, more as the years and months go by, and in Batty who in many ways became Fay, taking over her responsibilities. But there can be no second Fay. As Ray faded so fades Fay. To Batty, to Chip, to black.

I am lucky to have had Fay.

For information address Hyperion,
114 Fifth Avenue, New York, New York 10011

Edited by Howard W. Reeves
Design by Gary Tooth/Empire Design Studio

Printed in Hong Kong

Library of Congress
Cataloging-in-Publication Data
Wegman, William.
Fay / by William Wegman. – 1st ed.
p. cm.
ISBN 0-7868-6486-9
1. Photography of dogs. 2. Wegman, William. I. Title.
TR729.D6W42 1999
636.752--dc21 99-19821
 CIP

First Edition
10 9 8 7 6 5 4 3 2 1

Page 99: "Late Night with David Letterman"
photograph courtesy of NBC Studios.

Page 112, upper right corner: Reprinted with the
permission of Pocket Books, a Division of Simon &
Schuster, Inc. from THE HOUSE ON THE CLIFF by
Franklin W. Dixon. The Hardy Boys® is a registered
trademark of Simon & Schuster, Inc. Copyright ©
1927, 1959 by Simon & Schuster, Inc.

Acknowledgments

With thanks to
Virginia Alexander, Andrea Beeman, Caroline
Brackenridge, Jason Burch, Christine Burgin,
Allen Cohen, Betsy Connors, Madeleine de Sinety,
David Deutsch, Doyle Partners, DMZ/Benton
Bainbridge, Alexandra Edwards, Matt Garton,
Marvin Heiferman, Arnie Hernandez, Julie Hindley,
Hyperion, Barbara Jacobs, Janklow and Nesbit
Associates, Eric Jeffreys, Eric Johnsen, Carole
Kismaric, Martha Levin, Michael Lynton, Peter
MacGill, Lisa Martin, Dave McMillan, Heather
Murray, PaceWildensteinMacGill, Melinda Parsons,
Steve Philbrick and Bald Mountain Camps, Howard
Reeves, John Reuter, Linda Robinson, Dale Rubin,
Ed Ruscha, Victoria Sambonaris, Chris Schiavo,
Michael Schrom, Michael Shamberg, Arlene Sherman,
John Slyce, Michael Smith, Holly Solomon,
Katleen Sterck, Tracy and Tavi Storer, Gary Tooth,
Jeannette and John Ward, Pamela Wegman.

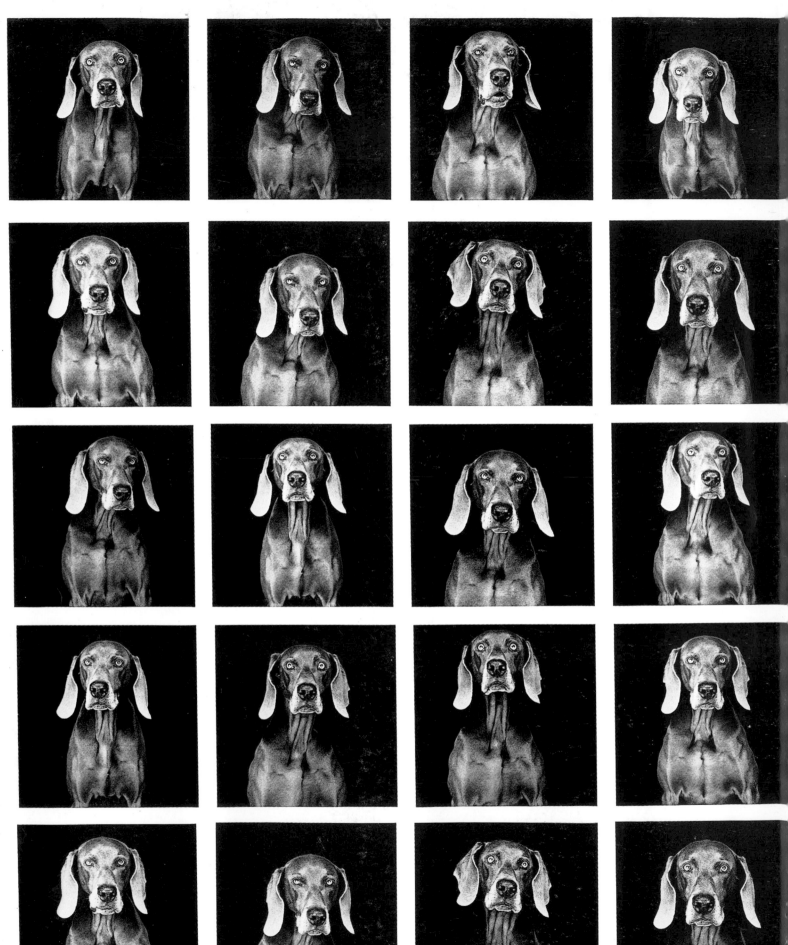